CREATING THE NEW CENTURY
Contemporary Art from the Dicke Collection

Essays by James F. Dicke II and Janice Driesbach

Catalogue texts by Ellie Bronson

Lucy Flint and Nikki Bruno Clapper, Editors

THE DAYTON ART INSTITUTE

Published on the occasion of the exhibition

Creating the New Century: Contemporary Art from the Dicke Collection
The Dayton Art Institute, March 12–July 10, 2011

ISBN 978-0-615-38031-5

Designed by Jennifer Perry, The Dayton Art Institute

Typeset in Gill Sans and Cochin

Printed on C2S Carolina Cover and Endurance Silk Text

Printed and bound in the United States of America by AGS Custom Graphics

Cover
Inka Essenhigh, *Spring*, 2006, oil on canvas, 72 × 62 in.

Back cover
Lisa Sanditz, *The Legend of Creve Coeur*, 2003, mixed media on canvas, 42 × 48 in.
Francesco Clemente, *The Weight of Light*, 2006, oil on linen, 74 × 81 in.
John Alexander, *Ship of Fools*, 2006-07, oil on canvas, 96 × 76 in.
Brian Calvin, *Turtlenecks*, 2007, acrylic on canvas, 48 × 60 in.
Amy Sillman, *Get the Moon*, 2006, oil on canvas, 80 × 69 in.

Frontispieces
Page 4 John Alexander, *Ship of Fools* (detail), 2006-07, oil on canvas, 96 × 76 in.
Page 8 Will Cotton, *Candy Curls (Melissa)* (detail), 2005-06, oil on linen, 34 × 34 in.
Page 16 Eric Fischl, *Four Generations of Dickes*, 2008, oil on canvas, 96 × 120 in.
Page 22 Inka Essenhigh, *Spring* (detail), 2006, oil on canvas, 72 × 62 in.
Page 170 Bill Jensen, *Ashes* (detail), 2004-06, oil on linen, 49 × 38 in.

CONTENTS

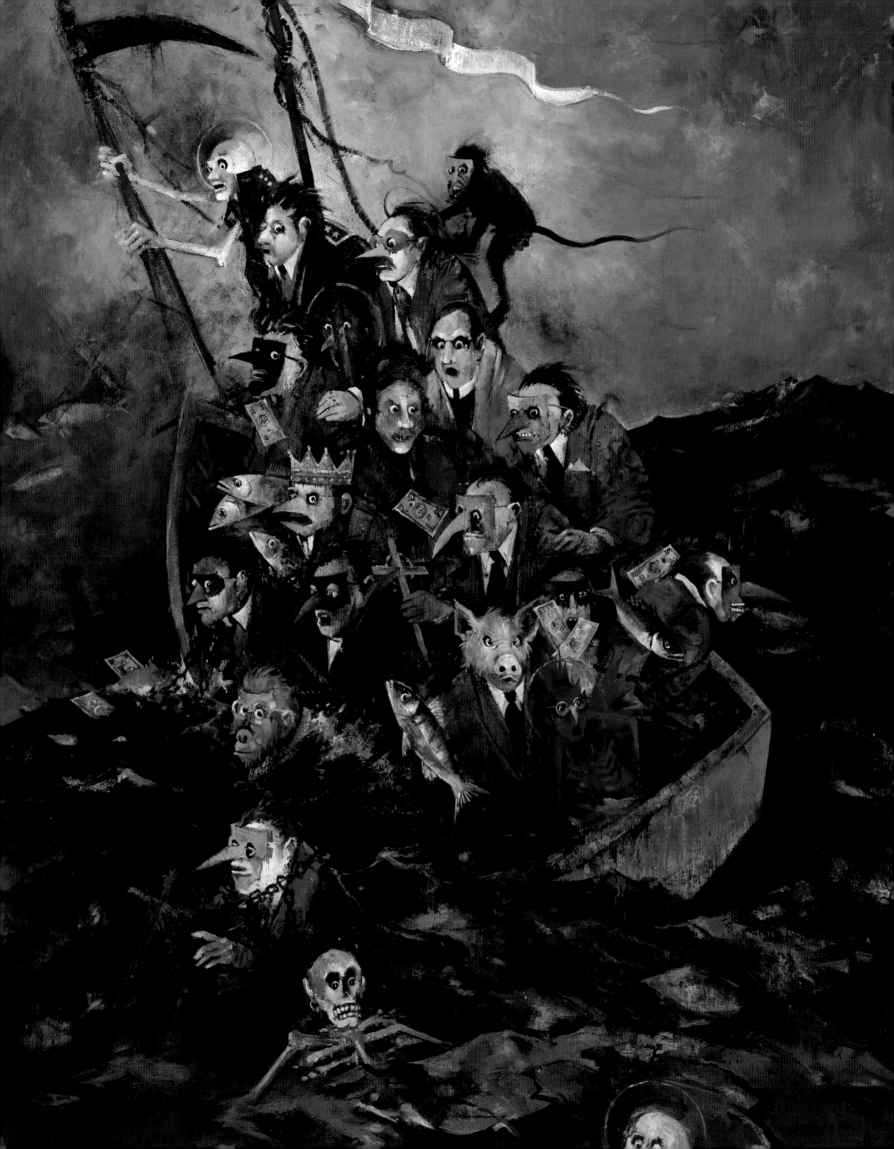

FOREWORD AND ACKNOWLEDGMENTS

Visitors to the Crown Equipment headquarters in New Bremen—a community in west central Ohio with some 2,900 residents—would scarcely expect to encounter John Alexander's *Ship of Fools*, Tomory Dodge's *Crush*, or a portrait of four generations of the corporation's owners by Eric Fischl in the art-filled entry. Nor would they anticipate that a newer office building not far away would be home to striking works by the likes of Brian Calvin, Mark Francis, and Lisa Sanditz, as well as classic examples by Sam Gilliam, Robert Natkin, Richard Serra, and other artists whose careers were established in the 1960s. These surprises are testimony to the collecting passions of the Dicke family, whose interests have encompassed historic homes, automobiles, art glass, 19th-century American painting, and the impressive contents of The Bicycle Museum of America they established on the town's main thoroughfare.

Exposed to art and art collecting by his mother, and early on inspired by a fellow Culver Military Academy alumnus to focus on American artists, James Dicke II has assembled holdings that reflect the breadth and depth of his interests. Armed with extraordinary energy, a sharp mind, a gracious manner, and an insatiable appetite for reading and learning, Jim Dicke exudes joy as he guides a visitor through his collection and shares his stories of how individual artworks were acquired. His admiration for America's past masters equals his engagement with young artists of today. In addition to his considerable accomplishments as chairman and CEO of the family-owned corporation, Dicke is an exhibiting painter himself and an informed contributor to the governance of nonprofit arts organizations, having served as chairman of the boards of trustees at The Dayton Art Institute and the Smithsonian American Art Museum.

In 1997 The Dayton Art Institute opened its new expansion by hosting American art from the Dicke collection, and it is with equal pleasure that we now share with our visitors the Dicke holdings of contemporary art, then in their infancy. It is particularly appropriate to present works by innovative artists in this institution, founded by pioneers such as Orville Wright, Charles F. Kettering, and the Patterson Brothers. Long committed to education—the Art Institute formerly operated a well-regarded art school and is now acknowledged for its outstanding family programs and collaborations with area schools—we take pride in presenting to our community of artists and arts enthusiasts a selection of outstanding works by established as well as upcoming artists.

The exhibition *Creating the New Century: Contemporary Art from the Dicke Collection* and its accompanying publication have come to fruition thanks to the dedication and generosity of many people. First of all, Jim Dicke has provided inspiration, insights, and resources that have allowed us to realize this ambitious undertaking. We thank him and his wife, Janet, for graciously sharing works from their collection. At the Crown Equipment Corporation, Julie Ahlers, senior executive assistant, has promptly and efficiently compiled information and images, and assistant treasurer Brad Smith has capably overseen financial arrangements. We acknowledge Tony Schott for assembling and preparing artworks for travel and Jodi Shimp for her outstanding photography of works in New Bremen.

At The Dayton Art Institute, assistant to the director Julia Dement and archivist Kristina Klepacz contributed to the compilation of catalogue materials; associate registrar Sally Kurtz ably oversaw all loan, shipping, and copyright arrangements; and exhibition designer and chief preparator Martin Pleiss and his outstanding assistants are responsible for the impressive installation. Our creative director, Jennifer Perry, contributed her considerable talents to the design of the catalogue and gallery texts, and director of education Susan Anable and her staff organized a full spectrum of interpretive strategies and programs to connect the exhibition with our diverse audiences. Deputy director of development and external affairs Dona Vella and marketing and communications manager Eric Brockman were instrumental in fundraising and promotional efforts for the exhibition and related activities. Our valued docents and volunteers and diligent security officers and building staff are also among the talented and dedicated museum personnel committed to assuring our visitors an outstanding exhibition experience.

We would also like to thank the following for their contributions, particularly the artists who submitted statements for this publication: Hannah Adkins, Galerie Lelong; Richard Aldrich; John Alexander; Gregory Amenoff; Kevin Appel; Hope Atherton; Linda Besemer; Mel Bochner; Carla Borel, Timothy Taylor Gallery; Mark Bradford; Scott Briscoe, Sikkema Jenkins & Co.; Cecily Brown; Chris Burnside, Cheim & Read; James Cahill, Sadie Coles HQ; Brian Calvin; Gillian Carnegie; Carla Chammas, CRG Gallery; Francesco Clemente; Tyler Coburn, Harris Lieberman; Ed Cohen; Leslie Cohen; Andy Collins; Carol Lee Corey, Danese; Will Cotton; Sascha Crasnow, Gladstone Gallery; John Currin; William Daniels; Elizabeth Deasy, CRG Gallery; Tyler Dobson, Team Gallery; Tomory Dodge; Peter Doig; Stef Driesen; Judith Eisler; Philip Ennik, Betty Cuningham Gallery; Inka Essenhigh; Marie Evans, Alexandre Gallery; Brian Fahlstrom; Eric Fischl; Louise Fishman; Lars Fisk; David Fitzgerald, Kerlin Gallery; Emily Florido, Gagosian Gallery; Caio Fonseca; Erin Fowler, Richard Grey Gallery; Mark Francis; Bernard Frize; Emily Goldstein, The Drawing Room; Sarah Granatir Bryan, Anthony Meier Fine Arts; Gotthard Graubner; Simon Greenberg, 303 Gallery; Tamsen Greene, Andrea Rosen Gallery; Gabriela Gutmann, Galerie Krobath; Nayla Hadchiti, CRG Gallery; Teneille Haggard, Andrea Rosen Gallery; Marc Handelman; Mary Heilmann; Allison Hester, Alexandre Gallery; Andrew Heyward; Rodney Hill, Marc Foxx; Shirazeh Houshiary; Elizabeth Hubbard, Gerald Peters Gallery; Jacqueline Humphries; Bryan Hunt; Katja Hupatz, Galerie Karsten Greve; Bill Jensen; Jun Kaneko; Alex Katz; Dwyer Kilcollin, Angles Gallery; Per Kirkeby; David Korty; Ricardo Kugelmas, Francesco Clemente Studio; Heike Langdon, The Kaneko; Daniel Lefcourt; Lauren Marinaro, Zach Feuer Gallery; Renée Martin, Blum & Poe; McDermott & McGough; James McKee, Gagosian Gallery; Erica Mercado, Marianne Boesky Gallery; Jocelyn Miller, David Zwirner; Wendy Miner; Marilyn Minter; Donald Moffett; Katy Moran; Chris Moss, Peter Freeman Inc.; Mariko Munro, 303 Gallery; Muntean/Rosenblum; Takashi Murakami; Yoshitomo Nara; Todd Norsten; Thomas Nozkowski; Heather Palmer, PaceWildenstein; Richard Patterson; Philip Pearlstein; Jesse Penridge, Richard Grey Gallery; Mae Petra-Wong, CRG Gallery; Serra Pradhan, Marianne Boesky Gallery; Richard Prince; David Ratcliff; Amelie Reisinger, Simon Lee Gallery; Renee Reyes, Andrea Rosen Gallery; Kath Roper-Caldbeck, The Modern Institute; Peter Rostovsky; Lisa Sanditz; Anna Schachte; Lindsay Scharfen, Patrick Painter Inc.; Amy Schmersal, Lehmann Maupin; Troia Schonlau, Jun Kaneko Studio; Dana Schutz; Sandra Scolnik; Sean Scully; Courtney B. Severin, Betty Cuningham Gallery; Amy Sillman; Karina Simbuerger, studio Muntean/Rosenblum; Josh Simpson; Amanda Snyder, Winston Wächter Fine Art; Pascal Spengemann, Taxter & Spengemann; Lauren Staub, PaceWildenstein; Fabienne Stephan, Salon 94; Kelly Sturhahn; Michael Werner; Tony Swain; Marc Swanson; Putri Tan, Gagosian Gallery; Kelly Taxter, Taxter & Spengemann; Liane Thatcher, Mary Heilmann Studio; Joanna Thornberry, Stuart Shave I Modern Art; Lia Trinka-Browner, Marc Foxx;

Reagan Upshaw, Gerald Peters Gallery; Juan Uslé; Alison Van Pelt; Tam Van Tran; Jeffrey Walkowiak, Sarah Meltzer Gallery; Ron Warren, Mary Boone Gallery; Tommy White; Carol Wiener, PaceWildenstein; Nicole Will, Bortolami Gallery; Margaret Williams, Caio Fonseca Studio; Sue Williams; Sam Windett; Clare Woods, Alisun Woolery; Marc Selwyn Fine Art; Sirui Yan, Salon 94; and Lisa Yuskavage.

Janice Driesbach
Director and CEO, The Dayton Art Institute

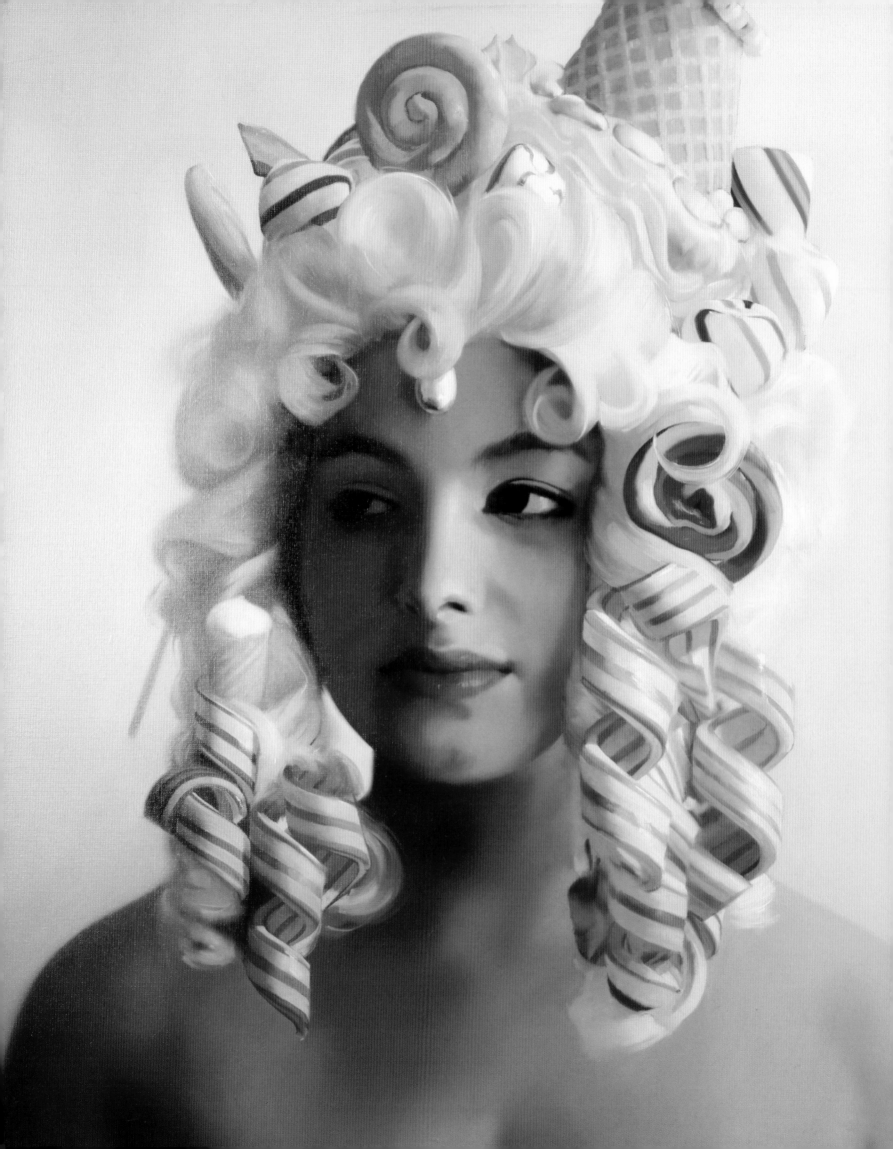

CREATING THE NEW CENTURY:
A Contemporary Art Collection

Janice Driesbach

When you collect within the time of your own life, you confront your own mortality, and the things you respond to . . . you enter into the metaphysical aspect of art and art history. The vocabulary is not just linear, it's like how light bends in time. History bends in time. And a collection bends in time.

—Jeff Koons, artist

Contemporary art challenges us, it broadens our horizons. It asks us to think beyond the limits of conventional wisdom.

—Eli Broad, art collector

The observations of Jeff Koons and Eli Broad about collecting in the continually fluctuating context of the present are salient in relation to *Creating a New Century: Contemporary Art from the Dicke Collection*, centered on a collector who is a practicing artist as well as a business leader. Eagerly seeking information of all kinds, Jim Dicke is finely tuned to the manifold simultaneous stimuli that characterize our experience of the world today.

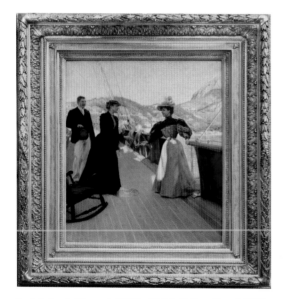

fig. 1. Julius L. Stewart (1855–1919), *Visit on Board*, 1896, oil on canvas, 31 7/8 × 25 1/2 in.

While referencing the diversity of contemporary artistic practice has become a cliché, it should be acknowledged that the range of expressions that comprise *Creating the New Century* also reflects the catholic tastes of the collector. Describing himself as "always eclectic in [my] purchases,"[1] Jim Dicke matches the breadth of the literature he ardently consumes with the expansiveness of his art collecting. He continues to acquire 19th-century American paintings while seeking out the latest works by today's young talents in studios and gallery previews. Julius L. Stewart (fig. 1), John Twachtman, Arthur Wesley Dow, and Doris Lee continue to inspire him even as new work by Mark Bradford attracts his attention.

Dicke's commission to Sam Gilliam for a triptych for a 30-foot wall in his Florida home paved the way for a shift in his primary focus away from historical American masters. After installing Gilliam's work, Dicke was eager to learn more about the artist and subsequently acquired more than twenty works by Gilliam, some dating back to the 1970s (fig. 2), a number of which he has donated to museums.

However, the real beginning of Dicke's contemporary art collecting dates to the early 1990s, with contacts who assisted him in navigating the complexities of its burgeoning market. As Dicke comments, by that time "contemporary art was so voluminous that knowing what was happening required full attention all day every day." Additionally, even as he favored

fig. 2. Sam Gilliam (b. 1933), *Cay*, 1975, acrylic on canvas, 72 × 129 in. © Sam Gilliam

earlier American artists who had not achieved great renown, there is an established framework for evaluating their works, one that does not exist for the art of our time.

Creating the New Century is comprised exclusively of art produced since the turn of the millennium, and, in the interest of representing a range of expressions, generally showcases only a single work by each artist. Fourteen of the 69 contributing artists were born after 1970, while others developed and were recognized for their mature styles during that same decade. Philip Pearlstein, whose lively portrait of Jim Dicke conveys their rapport, is the senior artist in the group, and Brian Fahlstrom the youngest. Some of the artists have had significant press attention while others have yet to receive substantial notice, evidence that Dicke is engaged by the qualities of the work itself and trusts his personal responses to it.

In many cases, artists featured in *Creating the New Century* are represented by multiple works in the Dicke collection. For example, Gregory Amenoff's *Rise* (fig. 3) and *Swale*, both intriguing compositions created close in time, are similar in character. However, Mark Bradford's recent untitled composition demonstrates a very different aspect of the artist's practice than does his magnificent *Helter Skelter I* of 2007 (fig. 4).

For the most part, the in-depth representation of living artists in the Dicke collection is testimony to longstanding friendships. Such is the case with Caio Fonseca, who the collector recounts as having made large-scale canvases using a Wave ("work assist vehicle") manufactured by the Crown Equipment Corporation. Perhaps the collector's knowledge of lift-truck components, or his own use of machines to generate abstract paintings that allude to the outer reaches of the universe or the inner realms of microscopic vision, stimulates his fascination with tools and process. He is clearly intrigued by how Fonseca refers to the abstract art form of music in images executed with an array of unconventional and sometimes whimsical tools—cardboard stencils, pizza wheels, and hair picks.

fig. 3. Gregory Amenoff (b. 1948), *Rise*, 2006, oil on panel, 19 3/4 × 19 3/4 in. © Gregory Amenoff Courtesy Alexandre Gallery, New York

fig. 4. Mark Bradford (b. 1961), *Helter Skelter I*, 2007, mixed media collage on canvas, 114 × 411 in. Courtesy of the artist and Sikkema Jenkins & Co., New York

fig. 5. John Alexander (b. 1946), *Goldilocks' Delight*, 1998, oil on canvas, 42 × 32 in. The Dayton Art Institute; Museum purchase with funds provided by the James F. Dicke Family, 1999.129 © John Alexander

John Alexander is represented in the Dicke collection by the dark landscape *Forest Scene*, the drawing *Angry Simian*, and the monumental *Ship of Fools*. Very different in character, but also reflective of Alexander's diverse talents—in this case, gardening—is *Goldilocks' Delight* (fig. 5). This lovely painting is one of the many generous donations Dicke has made to The Dayton Art Institute that have shaped both the early and contemporary American art collections. There is a certain irony in the fact that *Goldilocks' Delight*, filled with pristine yellow roses, should be in a museum collection while *Ship of Fools*, with dollar bills floating among doomed, masked Ensor-like figures, graces the foyer of a corporate office complex.

As a painter himself, Dicke is intrigued by how artists handle materials—for instance, the way Linda Besemer uses glass as a temporary support to create compositions that "are nothing but pure paint." He also savors the contrast between Will Cotton's cotton candy curls when viewed from afar and from up close. His decisions to acquire specific paintings or sculptures are sometimes based on their uncharacteristic aspects. For instance, when Dicke saw Bill Jensen's *Ashes* in a solo exhibition, he not only described it as the largest but also "the only dark painting in the entire show." Upon prolonged viewing, the work struck him as having a "Mark Rothko quality" that distinguished it from other examples by the artist. This occasional interest in acquiring works that depart from their creator's signature style likewise informed his purchase of Alex Katz's intriguing small painting *Tracy*, which depicts the subject with an ambiguity that is uncommon for this artist. Similarly, although the collector has admired Gotthard Graubner's work for 25 years, he deferred on making a purchase until he encountered *domino III*, one of the artist's rare small-scale compositions.

Concern with scale is not overarching for Dicke, and he has not allowed size to be a factor in his decision making. He went to considerable effort, for example, to reconfigure his New Bremen barn to accommodate Rachel Feinstein's *Sorbet Room* (fig. 6), a lavish all-white environment the artist created in response to a Rococo palace she had visited outside Munich. The installation is entered through an anteroom that sets it apart from the rest of the building, and the grounds outside the windows on the back wall were landscaped with Feinstein's input. Francesca DiMattio's oil on canvas *Collapse* (fig. 7) soars up more than nine feet. On acquiring Mark Bradford's 34-foot-long *Helter Skelter I* while it was on view in the New Museum's inaugural exhibition at its Bowery location, Dicke immediately offered it on loan to The Dayton Art Institute, where it filled the largest wall in the museum's sizable Rotunda entry.

fig. 6. Rachel Feinstein (b. 1971), *Sorbet Room*, 2001, wood and enamel paint, 144 × 188 × 276 in. © 2001 Rachel Feinstein

As painting is Jim Dicke's own artistic medium, the predominance of two-dimensional work in this selection is not surprising. Both figuration and abstraction are amply represented, and paint surfaces range from Brian Calvin's austere application to Per Kirkeby's and Bernard Frize's rich textures. Words form the content of several selections, as in Mel Bochner's and Mark Bradford's very different references to commerce. And others take direct or indirect inspiration from film, with Judith Eisler's *Steve McQueen (Bullitt)* and McDermott & McGough's *My Happiness is Misery* as primary examples.

A quality of mystery is prevalent among the works in *Creating the New Century* and characterizes much of the work in the Dicke collection. Gillian Carnegie obstructs our view into what we must presume to be a cemetery, Stef Driesen invites us to enter a disconcerting grotto that can be perceived as both positive and negative space, Eric Fischl asks us to bring our own experience to deciphering the tense relationship between his figures, and Tam Van Tran offers few clues to navigating his complex map.

A sense of motion is another recurrent motif, conveyed by the wave-tossed bark that dominates John Alexander's *Ship of Fools*, the simple yet complex spool of paint that bisects Ed Cohen's *Language is never owned*, the vibrant gestures with which Brian Fahlstrom and Louise Fishman develop their compositions, and the lines that activate Mary Heilmann's *Broken.*

Access to artists' studios and to exhibitions prior to their openings has often made it possible for Dicke to select from a wide range of new work. Among the studio visits that resulted in important purchases was one with Cecily Brown in

fig. 7. Francesca DiMattio (b. 1981), *Collapse*, 2006, oil on canvas, 112 x 68 in. © Francesca DiMattio and Salon 94, New York

fig. 8. Francesco Clemente (b. 1952), *Portrait of James Dicke*, 2006–07, oil on canvas, 46 x 92 in. © Francesco Clemente
Courtesy Mary Boone Gallery, New York

New York, which left Dicke impressed with the artist as a person and admiring of the attention she devotes to each of her compositions. The riotous explosion of forms and lush paint handling evident in *New Bunnies (El Greco)* are typical of the work that established Brown's reputation. As well, its title reflects the artist's open acknowledgment of past masters as generative influences.

Another artist Dicke readily notes liking as a person as well as a painter is Francesco Clemente, whose *Weight of Light* was also acquired during a studio visit. Around this time, Dicke sat for a portrait (fig. 8) by Clemente, who described his ambition to "show the person in his totality, beyond the narrative of age, and of time." Clemente continued to comment that his "portraits of women are more dynamic, and the background is colorful, to reflect the mutability of their role. In this portrait James Dicke is shown against a green background, which has just turned black. The black background, the weight of the hands, the verticality of the head, are all indications of stability and strength, qualities that agree with the role of a man. The portraits are always made in one sitting, from life, to capture the singular emotional tone of the subject. I enjoyed painting this one, but then, I always do."[2]

Among artworks that Dicke selected while visiting galleries prior to formal exhibition openings is Amy Sillman's *Get the Moon*. In this case, he encountered the artist while she was installing a solo exhibition at her New York gallery. Sillman shared that the canvas was one of the rare works that she liked from the beginning and had never felt a need to revisit after initially realizing its composition. Similarly, Dicke discovered *Krefeld Project, Sunroom, Scene #2 (Champagne)* at Eric Fischl's studio before the series was first presented at the Museum Haus Esters in Krefeld, so chose the work prior to its public display. In another instance, Dicke identified Inka Essenhigh's *Spring*, a classic example of the "Neo-Baroque" style with which the artist is associated, as his favored work in her one-person spring 2006 exhibition soon after it opened.

On occasion, as with the Clemente portrait, Dicke has commissioned work from an artist. However, other than portraits, Will Cotton's *Candy Curls (Melissa)* is a rare example of such an acquisition. This departure was motivated by Dicke's appreciation for a similar composition and his desire for a modestly scaled painting to embellish a small living room. Likewise, while Dicke enjoys attending art fairs, he describes them as "not an ideal way to see art." Nevertheless, he purchased Lisa Yuskavage's watercolors and Muntean/Rosenblum's untitled painting from New York fairs, and paintings by William Daniels and Sam Windett (fig. 9) at London's Frieze Art Fair. Indeed, Frieze may have piqued Dicke's interest in more fully representing British artists in a collection that, while including artists from Europe and Asia, resembles his holdings of 19th-century art in being dominated by Americans.

Critical to some acquisition decisions was the context in which works were to be displayed. Although Dicke does not shy away from placing provocative works in public spaces—witness John Alexander's *Ship of Fools*—he carefully considers

fig. 9. Sam Windett (b. 1977), *Sun and Road*, 2007, oil on canvas, 14 x 9 in. © Sam Windett and Marc Foxx, Los Angeles

fig. 10. Donald Moffett (b. 1955), *Lot 041000*, 2000, oil on linen mounted on wood, 12 x 9 ¾ in. © Donald Moffett

fig. 11. William Tucker (b. 1935), *The Emperor*, 2002, bronze, 65 x 78 x 44 in. © William Tucker

where they will be located in Crown offices. For example, Sue Williams's *Springtime for the RNC* was among the tamest of the beautiful, but risqué, canvases in her 2005 one-person exhibition. Likewise, while Mel Bochner's *Money* is thematically appropriate for the finance office wall on which it hangs, its words are less inflammatory than the vocabulary that peppers many of this artist's works.

Although each Crown area abounds with a variety of artistic styles, the individual artworks are thoughtfully selected, juxtaposed, and sequenced in the historic Crown Equipment Corporation headquarters. Compositions by Bill Jensen, Donald Moffett (fig. 10), and Dana Schutz are nestled among elegantly framed paintings by Childe Hassam, Francis Coates Jones, and John Carroll. A modestly scaled horse by Deborah Butterfield is situated not far from an Indian on horseback of similar dimensions by Cyrus Dallin, with Bryan Hunt's *Flume I* rising close to the ceiling in an adjoining annex. Visitors to the complex encounter, in close proximity, works by Doris Lee and Georges Schreiber, Manierre Dawson and Charles Seliger, and Marc Swanson and Toots Zynsky. A few blocks away, ancillary offices are filled with objects that, for the most part, date from the 1970s to the present, offering a visual history of Dicke's contemporary art collection.

The art that graces the Dicke residence and, most personally, the collector's nearby studio gives additional insight into his sensibility. On arriving, guests first encounter William Tucker's *The Emperor* (fig. 11), an upturned head in bronze that appears to emerge from the earth. Dicke appreciates that his maintenance people did not wax the sculpture's lumpy surfaces because "they thought it was rock," and notes that many people do not understand the work until he explains that it is a portrait of Ronald Reagan. Dicke comments that he appreciates the ambiguity of *The Emperor*, as well as how viewers bring their own life experiences to viewing it. Further, as a painter, he notes "liking to see how [Tucker] did it."

The installation of artworks in the Dicke home has many parallels with that in the central offices—a Dale Chihuly chandelier in the foyer welcomes visitors into rooms hung with works by 19th-century American masters. One room is filled with a stack of red plastic plates by Robert Therrien, while others feature works in glass, a collecting interest of Dicke's mother. All are a delight, yet the studio—a Craftsman-style structure a few steps away—is most revealing of what inspires the collector (fig. 12).

fig. 12. Dori and Joseph DeCamillis (both b. 1963), *The Price Is Right*, 1999, oil on board, 7 × 5 in. © Joseph and Dori DeCamillis

Filled with art, books, and CDs, the comfortable studio offers both respite and stimulation. The large central room and adjacent spaces are animated with smaller-scale, more intimate canvases and a smattering of sculpture. Artists represented range from Tonalist painters to Joan Mitchell and Marilyn Minter. This building, notably the interior stairway, also houses a number of drawings, by John Currin, Lisa Yuskavage, and others. In the larger space, Per Kirkeby's untitled painting occupies a corner close to Alex Katz's *Tracy;* across the room, Richard Patterson's *A Small Lot of Love* hangs high on the wall, level with Gotthard Graubner's *domino III.* The dense arrangement suggests that the collector considers these pieces sustaining rather than incidental.

All told, *Creating the New Century* presents a rich array of artworks created during the past decade that offers insights into artistic practice through the temperament of a collector. While some aspects of the art of this period, notably video and time-based media, are not represented, the artists featured—their styles, technical interests, and sources of inspiration—reflect a wide range of dynamic and original pursuits following the turn of the millennium. As Jim Dicke has remarked:

The artwork I find interesting, and the art I try to make, engages interest and tries to stop the viewer for a closer look. A certain element of ambiguity and beauty should address the senses. Is the image abstract or representational? Is it a view through a microscope or a view of space spanning millions of miles? As a matter of the physical painting itself, I hope the technique can be interesting and awaken a sense of questioning fascination. Wonderful works of art are interesting to live with each day and never lose their capacity to engage the viewer.

1 This and subsequent quotations of James Dicke II are from conversations with the author in New Bremen, Ohio, on December 2, 2009, and March 29, 2010.
2 Francesco Clemente, quoted in an e-mail message from Ricardo Kugelmas, Clemente Studio, to Ellie Bronson, December 15, 2009.

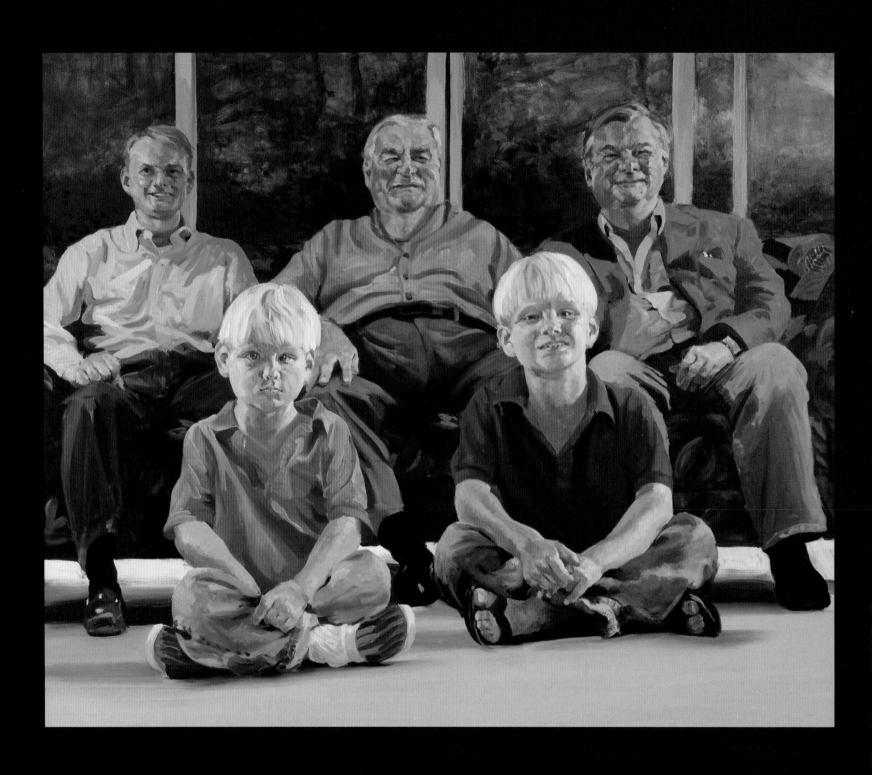

James F. Dicke II

At 10 years of age I spent a few dollars of savings to purchase a watercolor on paper. We still have it. In retrospect it seems like an unusual purchase for a young boy, but perhaps the bug for collecting had already arrived. Over the years, my appreciation for art and for collecting has evolved. I hope it has gotten more purposeful and focused, while at the same time retaining some of that childhood wonder and enthusiasm.

fig. I Jack Earl (b. 1934), *General Sherman*, 2007, ceramic, 28 1/2 x 22 x 16 1/8 in. © Jack Earl

My mother had an interest in art and was persistent about exposing our family to museums and giving us chances to see great art, both in person and through illustration. As a stroke of good fortune, Jack Earl, a leading American ceramic artist, taught art at my local public school in New Bremen, Ohio (fig. I). Later, in high school at Culver Military Academy, I received oil painting instruction from Warner Williams, Culver's artist in residence, and I have continued to be a part-time artist into adulthood (fig. 2). I believe that knowing how hard it is to paint and conducting a search for influences increase an art collector's appreciation for the talent a fine painting requires. This firsthand experience also helps the collector to understand how something was created.

As a young adult, when I found myself traveling for business on a weekend, I always enjoyed visiting local museums. When I could find a book about art or artists, their working methods or their lives, I eagerly read it.

When my wife, Janet, and I first started collecting art, it was with an eye to interior decorating. We were usually considering purchasing something for a particular spot. We would ask ourselves if the artwork could "fit in" with its future surroundings. What did we think of the frame? Did we enjoy the piece enough to make the purchase? Could we afford it? This was about as far as our analysis went. In those days we had very little concept of how to deal with condition, repair, or framing questions in a quality way.

The next turning point occurred in 1984. I attended a lecture by Sotheby's auction house executive John Marion, who said that more collectors should focus their purchases on the auction process as a place to buy, not just as a place for dealers to dominate for resale later. Marion's propositions were simplistic, but they made sense. I found I could attend an auction (or so it seemed) and bid with more confidence than I felt walking into a fine art gallery with checkbook in hand but insufficient knowledge. Today I know that auctions can have their tricky issues also.

There were some initial mistakes, but nothing that rose to the level of a stomach-turning "event." One small gaffe happened when I bought a painting titled *The Mouse Trap* (c. 1888) by the British artist Frederick Yates (1854–1919) and was surprised at its large size (37 1/2 x 30 3/4 in.) when it arrived. I had based my bid on a black-and-white photograph in the auction

catalogue—without seeing the painting in person—and had failed to pay attention to the dimensions. Somehow I had imagined a smaller size.

I did, however, know enough to ask the auction house for the condition report on an artwork. When the illustration was in black and white, the house would often be kind enough to send a color photograph to give me a rough idea of color. It was not a very informed way to make an art choice. There is never a good alternative to seeing art in person and at close range, assessing its condition, and viewing other originals by the same artist.

Slowly, over time, as I kept reading, looking, and learning from others, a more complete picture came into focus. I began to have more faith in my own eye for art, as well as my own informed idea of what a piece might be worth. Some people turn their art decisions over to "experts" in the field and reserve for themselves only the decision of whether they "like it" or not. For me, that approach would undermine knowing enough about the artwork to optimize the pleasure of living with it. Some people focus on a particular artist, period, or medium. We have tried to develop a more balanced approach that does not focus too narrowly on one area.

To collect art made since the year 2000, the focus of this current show, you especially need an informed, confident opinion of your own. When you can watch a group of art professionals have a lively discussion involving disagreement, it should begin to reinforce confidence in your own artistic view. With art collecting, you are almost always considering unique, one-of-a-kind objects. Questions of quality, desirability, rarity, condition, and the corresponding monetary values should inform every decision. You may determine the price by identifying the intersection where all these factors come together, not by examining the factors in isolation. As an example, the auctioneer Leslie Hindman once said, "When you hear the phrase 'slightly chipped,' you should focus on the word *chipped* and not the word *slightly*. The value difference between 'perfect' and 'slightly damaged' is significant." If an opportunity looks too good to be true, that's because it is.

fig. 2. James F. Dicke II (b. 1945), *Untitled,* 2009, mixed media on canvas, 54 in. diameter © James F. Dicke II

Every work you will see in this show was acquired with the collaboration of my friend, Jaime Frankfurt (fig. 3). An excellent art advisor knows what is going on in the art market in a way that can only be duplicated with a full-time effort. For example, if you, as a collector, have decided that you want to purchase something by Artist X, an advisor can help you assess the market, evaluate the works currently available, or even encourage you to wait for the right thing to come along. An advisor can also be candid with you about what he likes and what he does not like, as well as what he thinks is truly "important" artistically or not. It is critical to find an art advisor who shares your artistic sensibility—someone you really enjoy. Jaime and I have wandered the gallery scene in many cities and can stand in the middle of a show, look at a dozen wonderful works by an artist, and pick the same one or two as our own favorites almost every time. Our friendship, originally hatched around art and mutual good friends, has grown and deepened.

The best art advisors approach the work with an enormous dedication to integrity and a particular code of conduct. For some clients the advisor considers himself their eyes and ears in the art world, as he sorts out relevance and information while opening doors. For others he is a kind of informal art history professor, introducing them to the possibilities of the

art world. It is important for the advisor to make a distinction between *informing* a collector's taste and *creating* a collector's taste. It is important that he evaluate issues of provenance, quality, price, condition, the marketplace, and the relevance of a particular artwork to the artist's body of work. If a collector is to sell a work of art, the advisor tries to do what is best for the collector while being respectful of the artist and the gallery. Usually this can include offering the work to the gallery where it was purchased or to the artist's current dealer, while always keeping in mind that the sale is not just about money. Above all, the work should move to another good home. An ethical art advisor always works in the interests of the collector, never the dealer or the advisor himself.

Whatever financial arrangements exist, all transactions must be open and transparent. A good advisor never allows himself to be compensated in a way that is not disclosed to the collector. He will not, for example, accept both a retainer from the collector and a commission from the dealer. He does not have any undisclosed interest in the work for sale.

Consider using a part of your collecting budget to support artists of your own generation. The artwork of older eras exists today because an unbroken chain of people made the initial purchase when it was new and then continued to care for it. A collector should make an effort to support the art of his own time as a gift to future generations.

Since the year 2000, Jaime and I have focused primarily on the art of today. This has added an interesting dynamic of reliance on personal belief. When considering contemporary works, we do not have the luxury of evaluating art relative to an artist's full body of work. We also lack the advantage of knowing what the artist will do in the course of his life and where the artwork fits into the parade of art history.

The art of today can only be considered on the fly, without the benefit of knowing precisely where the story of art history will move next, how a particular piece will fit in the story, or even how the particular artist will evolve. It is like reading a newspaper every day, but still finding fascination with the summary and analysis later. The famous J. R. Simplot always drew a laugh when he would announce, "I don't know where we're going, but we're on our way." When you focus on today's artwork, this is a fun slogan to keep in mind. It is a time to trust your eye, advice you receive from valued sources, and your own taste in art.

As you collect contemporary art, be wary of the sales pitch. We live in an age when a responsible dealer will try to manage a contemporary artist's career to ensure stability and success. Will today's growing young star get stuck in his style and fail to evolve? Is the mid-career artist's work less interesting than it once was, or is the artist continuing to grow artistically? Does the older artist have a thousand back-room paintings that will one day come flood the market? Often you can never really know. Take refuge in the knowledge that no one should buy artwork as an investment. When a dealer mentions "investing," or an artist's growing prices, or a work's increased value due to the artist's age or death, these are reasons to be skeptical. As much as the grounded common sense of the artist or the skill and good judgment of a fine dealer can guide an artist to a fine career, success will still ultimately be about the work itself, its quality, and its power to engage viewers. The sales pitch should be put aside.

Information is the key word. Great dealers and auction houses spend decades trying to amass specific files of information not readily available to collectors. Where do paintings reside? Who owns them? Who owned them? What condition are they in, and what is the likelihood they can be brought to market? What are their desirability and rarity? Did Andy Warhol do four canvases of Jacqueline Kennedy, or did he do four hundred? Who are the likely collectors for a particular work,

and how might they feel about making a purchase right now? At the very expensive edge of the market, the number of potential buyers for a particular work will be small. Who might be available to the collector in his quest for additional expert opinions? What advice will those experts probably give?

As a collector, do you have museum connections that might be helpful? Perhaps you have a curator friend who might share advice, for example. Do you know a conservator or appraiser who has a particular expertise and lacks any stake in your decision to purchase or pass? How confident are you in your own knowledge about art? Have you read and studied? Have you seen—in person—many works by the artist in question? Do you know enough about the artist's life and travels to have a sense of where and how this particular piece fits into his body of work?

While information is important, a collector's knowledge will never be complete. Thankfully, as the decades have progressed, scientific testing answers more questions about artworks. The Internet is also beginning to help us answer more and more questions about the lives of artists and their work. Spend time learning about available online resources. The Internet allows a curious art researcher to gather in a few hours information that once would have taken months of traditional research. Hopefully, the time will come when we can view an online catalogue of the entire body of an artist's work and search it for relevant examples. Even then there will still be no substitute, no matter how good the information, for the experience of actually seeing an original piece of art in person.

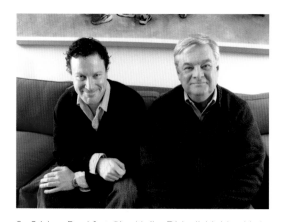

fig. 3 Jaime Frankfurt (l.) with Jim Dicke II (r.), New York City, 2010. Photograph by Pamela Hanson
© Pamela Hanson

Part of what I have found particularly fascinating about collecting the body of work you see in this show is the inclusion of great established artists as well as exciting newcomers. The work is beautifully done, but the beauty does not detract from significance. The first decade of the 21st century is captured here. It is not the complete story. It only shows a part of what would be ideal to include, but it is a snapshot of the dynamic time in which we live. Each artwork in this show was a pleasure to find and to acquire. Some of these selections appealed to my sense of art history. Others are exciting because of the amazing facility and originality an artist exhibits. Some are fresh with the energy and excitement of a talented newcomer. Each has its own story. I hope you will find this snapshot of the first ten years of the new millennium as fun and interesting as I found the collecting.

Finally, it is important to remember that living with an artwork is an evolving process. A purchase may seem like a wise decision at the moment, but over time the work does not continue to match the compelling first impression. Every collector has regrets. There are always stories of the one that got away, or the decision not made, that linger in memory. Perhaps the most interesting part of an art purchase decision is trying to anticipate and minimize regret. All collectors have limited resources. The decision to buy one work of art is also indirectly a decision not to buy another. As you stand before a particular artwork, ask yourself if you find it compelling enough to make the purchase. More important, if you do not make the purchase, will you regret the decision? The answer may not be readily apparent, and somewhat imponderable. Yet it is one of the final questions you should ask yourself before making the purchase or walking away.

WORKS IN THE EXHIBITION

Ellie Bronson

1

RICHARD ALDRICH

(b. 1975, Hampton, Virginia)
Untitled, 2008
Oil on canvas
84 × 58 in.

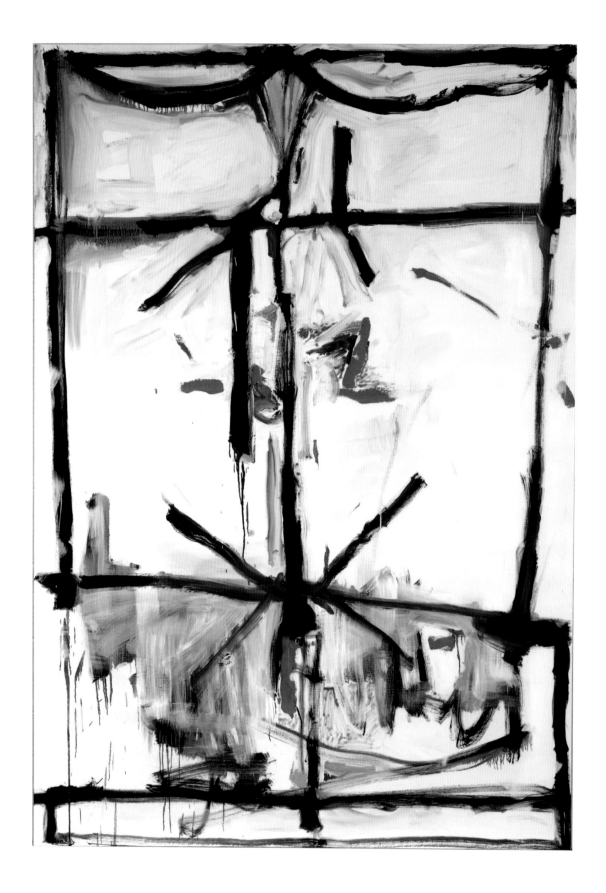

there is a sort of emptying that happens through an extraneous and short-term responsibility that is given to these paintings. they become detached from their original circumstances (emotions in a studio, a design . . .). this is their becoming decoration. this is temporary and contextual and not to be viewed as a lack as much as understood as an internal and interesting part of (their) existence . . . this ever-shimmering human condition.

The title of one of Richard Aldrich's works, *Painting as Revealing Three Gestures: Psychological, Structural and Philosophical* (2006), eloquently describes his sui generis art-making practice. In addition to both figurative and abstract painting, his work includes sculpture, collage, found objects, assemblage, personal mementos, and text, with a formal breadth that has been compared to Robert Rauschenberg's.[1] Though Aldrich shares with the late modern master a concern with media and methodology, unlike Rauschenberg he occasionally interjects a personal note, sometimes self-deprecating or playful in tone. The artworks in a single show can range from a figurative painting to a brown paper bag or carved troll.

The artist's multitude of stylistic choices reflects both his technical adroitness and exploratory nature. The latter is particularly evident in his use of text, both within and outside of paintings. Exhibitions of his work often include, or are accompanied by, his writing—whether a treatise on the concept of "flux" or an exposition on the word *psychedelic*. Aldrich's verbal eloquence complements his visual versatility, adding another dimension in which his art can be experienced and interpreted. The artist's recurring theme of a canvas cut away to reveal the stretcher beneath underscores his work's perceptual breadth. By revealing the work's fundamental structure, he questions the nature of painting's identity, constitution, and relevance.

Untitled exemplifies Aldrich's consummate skill as a painter; he presents a strong and daring composition using oil paint and canvas alone, with no cutting, collage, or text to strengthen the impact. He has carefully corralled drips and straight, brushy strokes, and his brushwork is further emphasized by the restricted palette of the predominantly brown and gray marks on the smudgy white background. *Untitled*, though abstract, evokes windowpanes through which one might hope to glimpse a truth about painting, or perhaps, at the very least, an interesting question.

1 Scott Rothkopf, "Openings: Richard Aldrich," *Artforum* 47 (April 2009), 170–73.

2

JOHN ALEXANDER

(b. 1945, Beaumont, Texas)
Ship of Fools, 2006–07
Oil on canvas
96 × 76 in.

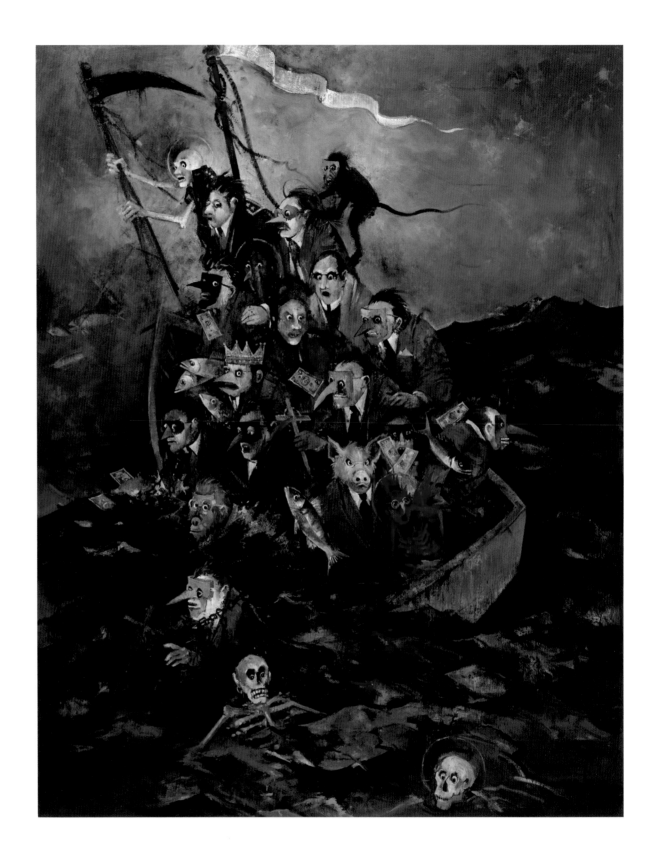

As a painter it is important for me to not only be aware of my own personal inner world but also to be aware of the broader external world around me. I think of **Ship of Fools** as an allegorical painting. I am on that ship . . . I know who each person is, what each person and object represents. Figuratively symbolic and atmospherically painted, **Ship of Fools** is resonant of my love of nature and historical events past and present. Hopefully, it is this connection between the painter and his environment that gives this painting its strength.

John Alexander has been described as an iconoclast and a satirist,[1] but it would be more accurate to classify him as an environmentalist and humanist. Born and raised in the oil-industry city of Beaumont, Texas, on the Gulf Coast, he has a passion for nature and the outdoors that has informed his work from his childhood sketches to his mature artistic output.[2] The bayou in Beaumont was filled with animals— owls, alligators, and raccoons, as well as mythical creatures from ghost stories, myths, and Voodoo—whose staring eyes later emerged in his work both as iconography and as a device for directly engaging his viewers. When one looks at Alexander's paintings, they look right back.

Coming of age during the era of the civil rights movement and the Vietnam War, Alexander has had a lifelong concern with social and political causes.[3] The themes of injustice and hypocrisy as well as collective guilt for the ills of society run strongly in his work. His mother was a devout Baptist,[4] and the Pentecostal conception of hellfire and damnation as the only alternative to a tenuous salvation led him to question the viability of religion in a country rife with inequality and false values. The title *Ship of Fools* is taken from the eponymous painting by Hieronymus Bosch (c. 1510–15), but in composition and content it shares more with Winslow Homer's *The Gulf Stream* (1899) and Théodore Géricault's *The Raft of the Medusa* (1818–19). The symbol of the boat as a metaphor for civilization is as old as Noah's Ark, though often, as in Alexander's interpretation, it is sinking. The cast of characters on this ship are uniformly ghoulish; if there is justice in the world, we can see why they are doomed. Each one represents an often-used icon in the artist's lexicon[5]—the masked man in a suit, the red devil, the pig-man, the skeleton, the monkey, and the Grim Reaper with his scythe, who appears at the bow of the sinking vessel. Greed is represented by the dollar bills floating around the figures and in the sea, vanity is the crowned man in a beaked mask, and religion the cross clutched by another figure, saving no one. Authority, represented by the captain in uniform, has Death as his copilot. It is worth noting that the artist inserts himself—masked like the others—into this apocalyptic scene, as if to suggest that he shares culpability for the tribulation he depicts. No one is an innocent bystander on the voyage of life. The wild eyes of the ill-fated passengers stare out of the canvas, meeting our gaze and drawing us in. We are all on the boat. Whatever pessimism one might read in the painting is offset by the elements of humor and the absurd. The scene we witness is a fable, a cautionary tale, and an agnostic invocation.

1 Ann Landi, "Fools and Ghouls," *ARTnews* 10 (January 2008), 106–09.
2 Julia Reed, "John Alexander's True Nature," *Garden & Gun* 5 (September/October 2008), 76–83.
3 Jane Livingston, "The Art of John Alexander," in Jane Livingston, Alison de Lima Greene, and Robert Hughes, *John Alexander: A Retrospective* (Houston: Museum of Fine Arts, 2008), 16.
4 Landi, "Fools and Ghouls," 107–08.
5 Livingston, "Art of John Alexander," 79.

GREGORY AMENOFF

(b. 1948, St. Charles, Illinois)
Swale, 2007
Oil on panel
34 × 36 in.

Swale is one in a group of paintings from an exhibition entitled **Facing North** shown at the Alexandre Gallery in New York City in 2007. It is the only nocturne in the group, and perhaps the painting that most clearly expresses the mystery, beauty, and despair of some of the northernmost expanses of our hemisphere's landscape. In a certain sense the most "living" elements of the worlds to the north are the heavens and the light they emit. While the foreground withers, the sky gleams. That is the essence of place I hoped to invoke in **Swale**.

Gregory Amenoff's semi-abstract landscapes are often so grand and dynamic that the artist seems to be a conduit for the force of nature itself. In his pictorial quest for transcendence, he seeks to cast off not only his own earthbound preoccupations,[1] but to free the viewer as well. He creates his landscapes with layers of oil paint, the thick textured surfaces of which appear not so much to conjure the rocky geometric land he depicts as to transmute into it. The visible strokes of the paintbrush or knife and the dabs of brilliant color evoke organic matter, reinforcing the painting's surface as an object itself, a thing in the world. The shamanistic aspect of Amenoff's work in this series extends to its conception: the composition is born entirely of his imagination, and he makes no preparatory sketches before starting to paint. Although the artist never portrays people in his work, humanity is strongly felt throughout his oeuvre; his visions are generously laid out for us—which begs the question, Would these brilliant skies and land masses exist at all if we weren't here to see them?

In *Swale*, Amenoff positions us in a valley (swale) below imposing snow-capped mountain peaks, beyond which we see brilliant stars and planets made of gestural blotches of lustrous white paint—a monochromatic aurora borealis. The deep blues and charcoal grays of the palette are mediated by the white snow and the vivid points of light, creating a mystical aura, whether emanating from the artist's brush, a greater Gaia force, or both.

1 Gregory Amenoff, "A Conversation with Bill Maynes," video, February 1, 2007, http://www.billmaynes.com/video5.html.

LINDA BESEMER

(b. 1957, South Bend, Indiana)
Fold #71, 2002
Acrylic, aluminum rod
72 x 72 x 2 3/4 in

For the last decade my paintings have been made as acrylic paint bodies that are displayed folded or rolled over rods or attached directly to the wall in a way that allows for their reattachment to different architectural environments. At a material level, the work has a deliberately ambiguous relationship to some of the ideologically constructed certainties of abstraction. Most obviously, they become paintings and sculpture simultaneously—embodying two-and three-dimensional elements. They also complicate the inherent visual and historical vocabularies of painting by blurring the fundamental formal and perceptual binary structures of painting: surface-ground; flat-spatial; front-back, etc.

Fold #71 is a 6-x-6 ft. painting and, like all my folds, is based on the "golden rectangle." The Golden Rectangle refers to a geometric rectangle ratio for classical ideal form in a painting. Each fold is made from a sheet of paint that is essentially a folded golden rectangle. In other words, **Fold #71** hangs at 6 x 6 ft. but is actually a 6-x-9-ft. sheet of paint folded at the "top" third. My interest was to find a way to make a painting that both reflected the history of ideal forms and undermined that history. The "image" of **Fold #71** consists of a grid made—not from hard edges—but rather of a series of vertical and horizontal gestures.

Subverting the traditional understanding of the medium of painting, Linda Besemer creates objects that defy classification. Made entirely of acrylic paint, they are built up layer by layer so thickly that the paint acts as its own support, eliminating the need for a canvas. Besemer reinvents paint as both a form and a medium. Her work can be interpreted as a feminist response to the way artists apply paint—an act of "masculine" domination over the passive, receiving, "feminine" canvas. Another aspect of the work that reinforces a feminist reading is the presentation of the "painting" draped over what could be a towel or curtain rod, referencing domestic environments, conventionally women's territory.[1]

Compared with the seeming insouciance of the finished work, Besemer's art-making process is laborious and complex. The *Fold* series is especially difficult to execute, as the works are double-sided. She first applies paint to a sheet of glass to form the top layer. Next she fills in the background with lines and grids, and bulks up the core with layers of white acrylic. She then works her way to the opposite surface, filling in the background and ending with a second foreground. When the paint dries, she peels the rubbery acrylic sheet off the glass and hangs it over a wall-mounted aluminum pole so that both sides are displayed.

In the *Fold* series, the folded grid of horizontal and vertical stripes appears from afar to form a single plane. In *Fold #71* Besemer has simultaneously channeled and inverted Op Art, a style in which the optical illusion of swelling or bending is generated in a flat work. Besemer's glossy reflective surface, with its intersections of brightly painted stripes, compounds our optical disorientation. Our first clue that the surface is actually two is the misalignment of the grids. Once we perceive the work's three-dimensionality, we can begin to appreciate the many elements that Besemer deftly brings together: painting and sculpture, front and back, surface and substance, form and content. In freeing painting from canvas, she opens up a world of possibilities.

1 Alice Thorson,"Shifting Colors:'ColorLove' presents a gallery of ideas in abstraction," *Kansas City Star*, September 29, 2002.

MEL BOCHNER

(b. 1940, Pittsburgh, Pennsylvania)
Money, 2005
Acrylic and oil on canvas
60 × 80 in.

The tone of these paintings has something to do with the evolution of language in contemporary public discourse, from the polite and respectful to the nasty and insulting. There is an implicit narrative in that downward spiral that these paintings attempt to track. Each painting begins with the more formal words and then devolves into words and phrases that refer to the body and its functions, from the prim and proper to the crude and vulgar. To me it's related to the philosopher Alain Badiou's observation that "in the world there are only languages and bodies."

I'm often asked if these paintings are meant to be funny. Am I **trying** to be funny? That question always reminds me of the following exchange in Martin Scorcese's film **Goodfellas** between Henry, played by Ray Liotta, and Tommy, played by Joe Pesci:

Henry: You're really funny.

Tommy: What do you mean funny? You mean funny "ha ha"? You mean funny the way I talk? What?

Henry: It's just . . . you know. You're just funny.

Tommy: Funny how? What's funny about it? Tell me how I'm funny? Funny like a clown? I amuse you? I'm here to fucking amuse you? What do you mean, funny? How am I funny?

Henry: You know, how you tell a story.

Tommy: No, I don't know. You said it. You said I'm funny. How am I funny? What the fuck is so funny about me? Tell me what's funny.

Henry: Get the fuck out of here, Tommy.

Tommy: Motherfucker! I almost had you there.

MEL BOCHNER

Mel Bochner's work daringly asks the question, What is art without language? Words are often the lens through which art is "seen"—in reviews, articles, and books—and they influence how we perceive and interpret it. What Bochner has accomplished throughout his groundbreaking career is to reposition words from the role of "filter" to that of subject and content. What happens when language is no longer used as a tool for processing experience, but becomes the experience itself? The game is changed. A gap in perception is closed, and the effect of the word-as-art is immediate and direct. One aspect of art survives this phenomenological shift: words can be just as subjective as pictures, equally reliant on the viewer's empirical perspective and consciousness.

Bochner's *Thesaurus* paintings, of which *Money* is a prime example, emerged from his quest for a new kind of portraiture composed entirely of words. Bochner refers to the thesaurus as a "warehouse for words,"[1] effectively democratizing his lexicon of choice. He begins by selecting an initial "key" word to describe his subject,[2] then makes a list of all the synonyms and related words and phrases he can find, edits it carefully, and maps out the order in which the selections will appear. He lets the words he finds take him where they may. Occasionally the journey includes slang and obscenity, but it is a trip worth taking, as we are guided through a sometimes vulgar or funny but always illuminating depiction of our linguistic culture.

Mirroring his artist statement published here, Bochner's word choices in *Money* run the gamut from the sacred to the profane. "Root of all evil" and "filthy lucre" are taken from the New Testament, the First Epistle to Timothy: "The love of money is the root of all evil" and "not greedy for filthy lucre" (1 Timothy 6:10 and 3:3, respectively). "Liquid assets" is a term popularized by Wall Street. "Mazuma" and "gelt" are Yiddish slang. Bochner's statement pulls from sources as diverse as the writings of the French philosopher Alain Badiou and the obscenity-peppered screenplay for the movie *Goodfellas* written by Martin Scorsese and Nicholas Pileggi—a tale of Mafia

violence and vulgarity. This diversity exemplifies the breadth of the artist's interests and inspiration, like a Venn diagram illustrating an intersection of high and low culture where academia, etymology, and entertainment meet.

Bochner determines in advance how many lines the painting will have and how many letters will fit on each line. The use of color in these paintings is deliberate as well—the artist's intention is to defy a linear reading of the words,[3] varying his palette to illustrate and evoke emotion. He does not plan ahead which colors to use; he improvises from one word to the next, not knowing what the finished painting will contain until he paints the final word. This technique alters the way we interact with the work. Rather than easily "reading" it, we "see" it the way we do an abstract painting or a landscape—our eyes roam over the canvas, drawn by bright light colors, seeking out and finding word-forms almost camouflaged by the background. In the *Thesaurus* paintings, Bochner uses both semantic and aesthetic exploration to bring us to a new understanding of the opacity of language.

1 Quoted in Mark Godfrey, "Language Factory," *Frieze Magazine* 87 (November–December 2004), http://www.frieze.com/issue/article/language_factory/.
2 Ibid.
3 Mel Bochner, *Solar System & Rest Rooms: Writings and Interviews 1965–2007* (Cambridge, Mass.: MIT Press, 2008), 204.

6

MARK BRADFORD

(b. 1961, Los Angeles, California)
Untitled, 2009
Mixed media collage
20 1/2 × 22 1/4 in.

This particular poster I saw in only upper-middle-class neighborhoods and I was struck by the smartness of how economic mobility also brings with it another set of economic possibilities. Only middle-class people pay to have their gutters cleaned! Somebody figured that out and started a business servicing that community; people pay attention.

Mark Bradford is fascinated by the unregulated informal commerce that takes place every day in his native South Central Los Angeles. After the Rodney King riots in 1992, so many homes and businesses had been burned to the ground that the city erected cyclone (chain-link) fencing around the vacant lots to keep them from being colonized or appropriated for unsavory purposes. On the outside of these fences handmade signs for undocumented micro-businesses run by people from the neighborhood began to appear. These signs, or "merchant posters," tell the economic, cultural, and social story of the neighborhood, advertising services such as "Immigration Papers in 30 Days or Less," "Cash for Your House," "Divorce and Custody," "Pest Control," "Drug-Free Safe Home," "Hair Weaves and Extensions," and "DNA Paternity Testing (Is This Child Yours?)."

Bradford explains that he comes from generations of merchants; his grandmother and mother were a seamstress and hairdresser respectively. When he was old enough, he had a brief tenure in his mother's hair salon—she let him not only style hair but also hand-letter the price signs in the beauty parlor window; he taught himself calligraphy in order to make the signs, as he says, "very fancy."[1]

These days the artist walks the streets looking for merchant posters that he pulls off the chain-link fences and brings back to his studio, where he begins the process of simultaneously destroying them and transforming them into artworks. First, he outlines the letters with mason string or snap line. After securely gluing the twine to the poster he flips it face down to dry so the surface conforms to the outlines of the letters. Next, he covers the poster and string with layers of paper,

repeatedly sanding down the glued layers with an orbital sander to rediscover the quasi-obscured lettering. This process of simultaneous collage and décollage goes to the heart of Bradford's art-making practice. He notices and celebrates the ghost economies of his city, what happens "off the grid." Rather than fabricating the posters in his studio, he uses found signs because they carry with them the memories of where they came from—they already have a history, which he maps out in a painting that tells a story.

Bradford is fluent in many media—painting, printmaking, sculpture, photography, and film—but returns again and again to interaction with daily life on the streets of L.A. There is always more to discover and applaud. He has created a number of high-profile projects, including an ark built of found materials in the Lower 9th Ward of New Orleans after Hurricane Katrina for the Prospect.1 New Orleans Biennial (2008–09) and the *Malateros* project of 2005 for *Farsites* (a collaboration between the San Diego Museum of Art and the Centro Cultural Tijuana), in which he furnished shopping carts to the porters who carry the luggage of people who walk across the San Diego/Tijuana border daily. This latter project gave rise to a number of side businesses, with the "licensed" porters leasing their carts to others, which prompted the following comment from the delighted artist: "Everybody's got a hustle, and that's okay too."[2]

1 Art 21, "Paradox: Contemporary Artists address contradiction, ambiguity, and truth," PBS video, 54:25, http://video.pbs.org/video/1239798931.
2 Mark Bradford, lecture in the series Seminars with Artists, Whitney Museum of American Art, New York, N.Y., May 3, 2006.

7

CECILY BROWN

(b. 1969, London, England)
New Bunnies (El Greco), 2001
Oil on linen
48 × 60 1/4 in.

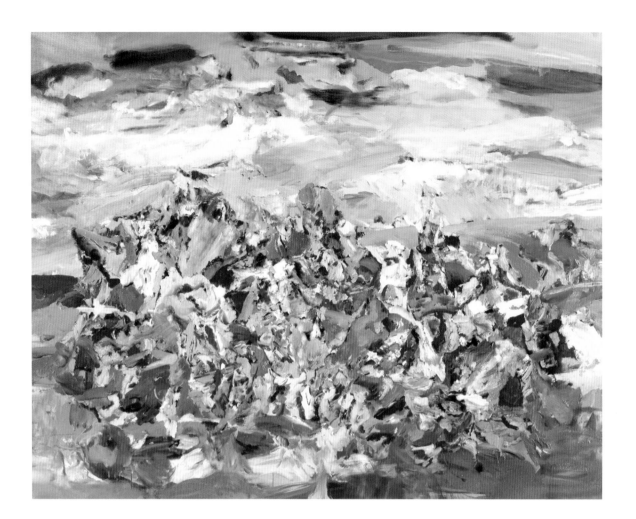

CECILY BROWN

New Bunnies (El Greco) was part of a group of paintings of bunnies in landscapes. The bunnies and other animals and figures have become a seething mass of parts. I was thinking of **Christ Driving the Traders from the Temple** by El Greco, and the way that the movement of the figures conjoins them. They are both buoyant and still. I wanted that feeling of bound energy, but seen at high speed.

The painting by El Greco that Cecily Brown references in *New Bunnies (El Greco)* depicts the biblical legend of Christ expelling the money-lenders and traders from the Temple in Jerusalem, in which a teeming mass of bodies pulsates with aggregate energy. In Brown's interpretation, the people are reimagined as nascent bunny forms, so abstract as to be almost entirely camouflaged save for the occasional hint of white or brown tails, ears, or paws. Her bunnies are stand-ins for humans, whom she paints in various states of undress and *in flagrante delicto*, in images radically varying in style from the overtly figurative to the abstract. This simultaneous concealing and revealing is central to Brown's artistic intention. She wants the viewer to experience her paintings as we experience life—the longer we participate, the more is unveiled and the greater the rewards for our attention.[1]

Brown works primarily in oil on canvas, using brushes made of squirrel and ox hair, with extra-long handles that allow her to move toward and away from her works in progress at will, zeroing in on details and stepping back to see the big picture, just as the viewer might experience it. A prolific painter, she works on as many as 20 large canvases at once, each one engaging with the others, and with her, in a kind of conversation. She has said that sometimes they whisper to her behind her back,[2] calling to her with ideas and begging for color. Brown is a skilled colorist who confesses to getting "crushes" on colors,[3] returning again and again to warm shades of lavender, pink, and red. Her affection for her medium borders on physical attraction: lush gobs and smears of paint coat her surfaces, seducing us with their rich color and opulent application.

New Bunnies (El Greco) is an exuberant pastoral, with indeterminate splashes of colorful forms creating a mound in the foreground, against a sloping green horizon line. Above the joyful grappling and the grassy slope, a beautiful turquoise and white sky roils like a turbulent sea. The painting is infused with natural energy—the melee in the foreground is echoed by the windy sky, all seemingly part of the bunnies' bacchanal. The overall effect is a slightly disordered, earthy dynamism. One might be reminded of the legendary proclivities of rabbits—their purported enthusiasm for, and success at, procreation. Brown's painting is a celebration of fecundity and life.

1 Cecily Brown, "Interview by Perri Lewis," *Observer* (London), September 20, 2009, http://www.guardian.co.uk/artanddesign/2009/sep/20/guide-to-painting-cecily-brown.
2 Robert Enright, "Paint Whisperer: An Interview with Cecily Brown," *Border Crossings* 93 (February 2005), 38.
3 Ibid., 37.

8

BRIAN CALVIN

(b. 1969, Visalia, California)
Turtlenecks, 2007
Acrylic on canvas
48 × 60 in.

I am more concerned with specificity in painting than with realism. Obviously, a painting is just the result of a series of decisions the painter makes. I work on paintings until I sense a satisfying inner logic. More recently, I feel like the paintings freeze themselves into place. They show you what they show you. I'm not trying to accomplish anything for them. I haven't figured anything out already or in advance. Along that same line, I don't think painters control the meaning of their work. Later on, meaning might circulate around the painting. This may or may not make sense to the painter. I sense meaning in my own painting, but I can't really verbalize it—I hope that meaning exists outside of language. I think more clearly through painting. I spend a lot of my hours painting, and the bulk of painting is thinking. Painting is thinking distilled. Painting is thinking.

Brian Calvin's enigmatic paintings of androgynous, vacant youths have earned him comparisons with the artists David Hockney and Alex Katz.[1] Calvin's world, however, is slightly gloomier than theirs, like Hockney's without the sunshine or Katz's without the hint of narrative. His work has been described as "slacker" art,[2] implying the absence of effort or activity, but this is misleading. The label "slacker," used to describe members of the culturally classified Generation X, implies underachievement, even failure. The iconic slacker grew up in the 1980s and, rebelling against that decade's emphasis on striving and success, as a young adult worked at menial day jobs, worshipped beautiful train wrecks like Kurt Cobain, Jeff Buckley, and Elliot Smith, and was cemented in popular culture by movies such as *Reality Bites* and anything by Richard Linklater. Whatever Calvin's taste in music, movies, or art, the label cannot be applied to him as an artist because he clearly labors to create the impression of ennui.[3] His canvases are finely worked—down to the minute details of their often drab backgrounds.

Calvin's cast of characters seem paused or dormant, cryogenically frozen, to be reanimated at a later date—or not. They are uniformly skinny, with closed mouths and large pooling eyes that invariably function as the focal point of the composition. Frequently, the figures are reduced almost entirely to their formal role as shapes in gradated color. The artist's work is not about individual identity; it is more likely about its absence.

Turtlenecks is a quintessential example of Calvin's most stripped-down work. Two women appear in echoing poses, dressed almost identically in beige turtlenecks. One could be the mirror image of the other, save for the bright red lipstick on the pouty mouth of the right-hand figure. Their hair is pulled back into wispy buns, their necks are exaggeratedly long, and their shoulders point upward in a shared shrug. Emotion is conveyed only, and ambiguously, by their red-rimmed eyes. One looks slightly upward, while the other stares straight out of the canvas, meeting the eyes of the viewer in what might be a question, a reproach, or a loving gaze. We want to rescue these women from their disconcerting sameness—if they are twins, they don't seem too happy about it. We can only guess what might have led the artist to imagine these gawky, sad-eyed women in their watchful uniformity. Could it be the struggle to define individual identity in a culture too quick to categorize and aggregate? The answer lies in the viewer's own reaction.

1 Ken Johnson, "Art in Review: Brian Calvin at Anton Kern," *New York Times*, September 17, 2004.
2 Michael Wilson, "Brian Calvin," *Artforum* 43 (December 2004), 195.
3 Jennifer Higgie, "Brian Calvin," *Frieze* 61 (September 2001), 89, 96.

GILLIAN CARNEGIE

(b. 1971, Suffolk, England)
Cemetery Gate, 2006
Oil on canvas
83 × 60 1/4 in.

In 2005 the art world was shocked when Gillian Carnegie was shortlisted for Britain's Turner prize despite making work that is not—at first impression—very shocking.[1] This award has famously been given to artists such as Jake and Dinos Chapman, Tracy Emin, and Damien Hirst, whose pornographic sculptures, public drunkenness, and fixation on death (respectively) have made headlines around the world. Carnegie, however, does something arguably more outrageous than these artists; she presents traditional subject matter in a traditional way. She is interested in painting itself.

Though her subjects are conventional—flower arrangements, landscapes, portraits, buildings, and partial nudes (her own backside is a recurring theme)—her handling of them is not. She paints with the greatest of unease, discomforting us by her very brushwork, which alternates between thin washes, wide and visible strokes, and gobby impastos of paint. She uses a subdued, earthy, almost drab palette that is seemingly on the verge of evanescence. With technical, stylistic, and formal dexterity, she elicits an enigmatic and draining claustrophobia.

Cemetery Gate allows us a glimpse into the artist's working method while characteristically keeping us at arm's length. Carnegie begins by taking photographs, and then sequesters herself in her studio to spend hours working out compositions and making preparatory studies in oil on paper and canvas. She will often combine source photographs, as one suspects she has in *Cemetery Gate*—for where on earth are there such incongruously neat tiles (linoleum?) leading to a graveyard? It is not only such overt incongruities that startle us, it is also that at almost every turn the artist has visually closed us out.

When we see her figure, it is only from behind. When she paints windows, the curtains are drawn. When she depicts a wall, there is no end in sight and no way around. The cemetery gates are shut and, we imagine, locked.

While Carnegie may not be an easy artist to access—she is notoriously as private as her work suggests[2]—she rewards the viewer with a beauty made all the more poignant by the subtlety of her style. The square blocks of shaded color on the archway of *Cemetery Gate* can make one ache with quiet nostalgia.

1 Marcus Field, "Gillian Carnegie: Flower Power," *Independent* (London), June 5, 2005.
2 Ibid.

10

FRANCESCO CLEMENTE

(b. 1952, Naples, Italy)
The Weight of Light, 2006
Oil on linen
74 × 81 in.

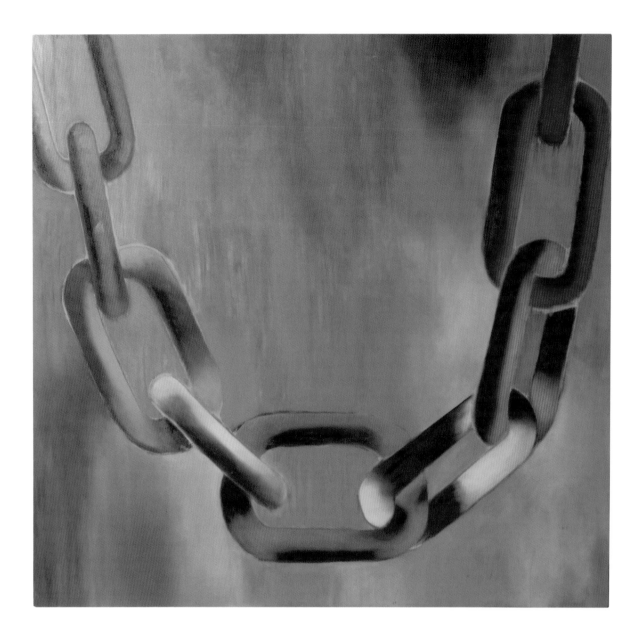

At its core my work is political. I believe the task of the artist is to be a traitor, and offer an alternative narrative to that of his community. The view that sustains my work is summed up in the simple statement "Everything is real, and everything is changing."

My goal is to portray experience as "the continuity of discontinuity." My tool is the constant renewal of ground, medium, and geographical setting in the making of the work. New materials allow new groups of images to emerge, and to create a momentary narrative. Then, when the works are dispersed, they remain as fragments of a story that has been lost.

The Weight of Light is part of a group of paintings made after a journey to Brazil. The iron of the chain and the colors of the rainbow are important in the iconography of Candomble traditions. The green-gray is the color of the Atlantic. But the iconographical references are only points of departure; the goal is to show an image in a transient state, a relative tool that opens a view of the absolute.

Francesco Clemente's work depicts a world in flux. Born in Italy, in his teen years he made his first journey to India, where his worldview was exponentially enlarged and he became, philosophically and practically, a citizen of the world. He developed a lifelong enthusiasm for Hindu spirituality in particular[1] and world religions and culture in general. This experience led him to cultivate an attitude of openness toward all things and people—a state of almost perfect vulnerability to experience and knowledge. Clemente believes that in order to be a great artist you must first be a great listener.[2] In the service of this belief he is a frequent, curious, and informed traveler, which, with his interest in native culture and spirituality, contributes to the immediacy and force of his work.

In *The Weight of Light* Clemente references the colors and icons of Candomble, a centuries-old Afro-Brazilian religion. Candomble, which came to Brazil with the African diaspora, is rooted in animism—the idea that nature and the universe itself possess souls. This idea appeals to Clemente, who believes that it is essential that one not cling to transient moments or things, and instead let life unfold gracefully in accordance with universal rhythms.[3] The background color of the painting refers to the ocean, the ebb and flow of which epitomizes this dynamic energy. The naturally occurring element of iron and the icon of the chain are symbols of strength in many cultures. The evolving progression of the rainbow colors in the chain conjures moments that are simultaneously concrete and fleeting. *The Weight of Light*, an exemplary depiction of Clemente's ethos, invites contemplation and mindfulness.

1 Brooks Adams, "On the road to a state of grace," *Tate, etc.* 13 (Summer 2008), https://www.tate.org.uk/tateetc/issue13/grace.htm.
2 Charlie Rose, "A Conversation with Francesco Clemente," video, 43:14, August 20, 2008, http://www.charlierose.com/view/interview/9227.
3 Ibid.

ED COHEN

(b. 1942, Scarsdale, New York)
Language is never owned, 2006
Acrylic on canvas
24 × 18 in.

I attempt to express states of mind, emotions, forms of energy, ideas that are beyond words.
The painting seeks to establish a relationship with the Other founded on desire and mystery.
My way of painting discovers form through the flow of the paint.
I want engagement with the painting to involve a sense of meditation, a reflection of the possibility of inner silence.
The relationship of cosmic forms (and gases) to the myriad natural earthbound forms interests me.
My way of painting is influenced by Enso paintings of 17th-century Japanese Buddhist monks.
The line and the circle may be infinite.

Ed Cohen's artwork is a spiritual journey. Though his process and handling of paint invite comparison with Jackson Pollock,[1] the result is not the frenzied abandon of Pollock's abstract expressionism, but a contemplative exploration of the infinite and the unknowable. He is inspired by Buddhist philosophy, which emphasizes the importance of meditation and mindfulness in daily experience in order to allow the practitioner to gain insight into questions of existence, a central goal of the quest for enlightenment.

Cohen begins by placing his canvas on the floor and coating it with a thick layer of black or white acrylic, then carefully prepares the paints he will apply. At this point, all predetermination ends. He moves around and over the canvas, dripping paint in splatters and globs of color. The process precludes any alteration, reversal, or revision. Elements of chance and infinite variation come into play, which the artist encourages by titling works with phrases culled from poetry and philosophy, adding evocative verbal clues to the already myriad subtle visual stimuli.

Cohen's subject matter is closely related to the *enso* (in Japanese, "circle") paintings of Buddhist monks in which the monks paint a circle over and over again as a meditation practice. This circle symbolizes a moment of perfect creation, when the mind is unfettered by thoughts and worldly concerns. Cohen's trails and lacy weaves of paint are more intricate and complex than the monks' paintings. He paints not only circles,

but arcs, diagonals, and straight lines composed of drips and swirls that flow from one side of the canvas to another. When the form is linear, as it is in *Language is never owned*, it depicts the eternal; in the artist's conception, the canvas does not end but extends infinitely. The undulating patterns and designs are sometimes brilliantly colorful, and sometimes almost monochromatic. In either case, they relate equally to the macro and micro—they could be DNA strands or the Milky Way. Cohen is intrigued by cosmology[2] and this interest in science encourages an interpretation of his paintings in relation to chaos theory, which holds that systems that appear to be chaotic may actually have an order and structure, however hard to predict. The lyrical swirls of paint have a rhythm and motion all their own—at first seeming random and unknowable, but on contemplation revealing hints of subtle harmony.

1 "Ed Cohen: The Nothing That Is Not Here," Winston Wächter Gallery press release, http://www.winstonwachter.com/2009/ny/exhibitions_ny_cohen.php.
2 Darian Leader, *Ed Cohen* (New York: Jeannie Freilich Contemporary, 2008), unpag.

12

ANDY COLLINS

(b. 1971, Atlanta, Georgia)
Untitled, 2001
Oil and alkyd on canvas
73 × 78 in.

Andy Collins's large paintings have the pleasing palette of ice-cream cones or Easter eggs. Their linear designs evoke the biomorphic abstraction of Ellsworth Kelly's plant drawings and their pastel color fields and flat overlapping shapes call to mind the paintings of Gary Hume. Though Collins may intend a reference to these older artists, his subject is fashion photography, albeit abstracted and greatly removed from its source material.

Collins zeroes in on easily overlooked details in glossy high-fashion spreads: the folds and creases of fabric, plunging necklines or subtly draped hemlines, the model's knees, elbows, or armpits. He notices the places where the clothing conforms to the topography of its wearer[1]—a telltale sign of humanity beneath the glamour. Once he has selected a photograph that intrigues him, he works out the idea in a series of graphite sketches, increasingly abstracting the image and progressively veiling the hints of physicality. When a new image has emerged during the drawing stage, Collins begins an arduous process of paint application that takes many months to complete. He applies up to 30 layers of oil and alkyd by hand, though the finished work reveals little or no evidence of brushwork.

Untitled resembles a flower, its trembling petals opening up from an invisible center. The artist has effected the intriguing transmutation of a found image reflecting the synthetic allure of fashion into a suggestion of natural beauty. Although designers throughout history have been inspired by nature, it can be difficult to see the connection in the highly polished and digitally enhanced spreads of contemporary fashion magazines. By bringing forth subliminal patterns and designs, Collins celebrates the appeal of the lines, forms, and colors that likely inspire the designers themselves.

1 Bill Arning, "Andy Collins at Massimo Audiello," Art in America 87 (October 1999), 170.

13

WILL COTTON

(b. 1965, Melrose, Massachusetts)
Candy Curls (Melissa), 2005–06
Oil on linen
34 x 34 in.

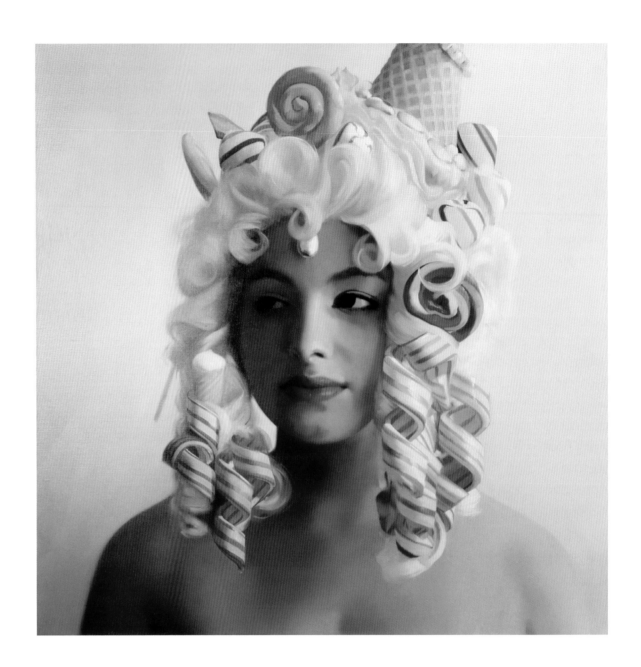

This painting came out of my ongoing exploration of the issues of desire and excess as they relate to adornment. I've made reference to the types of decoration often applied to people and sweets in the interest of making them more appealing. The wig the sitter wears in this picture is based on the fashions of the court of Louis the Sixteenth, one of the prime historical examples of decorative excess.

While Will Cotton has drawn inspiration from sources as widespread as William-Adolphe Bouguereau, Hudson River School painters such as Frederic Edwin Church, and classic pinups, he credits the children's board game Candyland with giving rise to his saccharine landscapes.[1] The artist is an accomplished pastry chef and, with the aid of tools such as a professional-grade oven and a fog machine, he constructs elaborate models of a world where everything is sweet. He builds giant pillows of cotton candy, poses live models as modern-day odalisques, and fashions gingerbread houses with decorative cartoonish eaves and alps made of spun sugar and candy canes. He sketches and takes digital photographs to capture his creations before the inevitable toll of time melts both sugary treats and models alike.

Cotton's paintings take flight from these concoctions, depicting an alternate reality where women are exaggerated archetypes of a particular kind of stylized femininity, equally alluring and alarming: Barbie dolls in a delicious paradise that would make you ill if consumed too quickly. At galleries, he and a small fleet of attractive assistants crowned with cupcake headdresses have served visitors macaroons and tarts. His own sweet-tooth cravings run the gamut from store-bought Halloween candy to 10-course dessert tastings at 5-star restaurants.

Cotton's aesthetic quest is for the turning point where sweet becomes sickly—between glamorous indulgence and guilty gluttony.[2] It is easy to understand why the artist is fascinated by dessert and its inherent conceptual paradox—for all its pleasure it provides no nourishment, and more often than not is quite bad for you. Sweets can make you sick if you eat too many; if you indulge in unchecked habitual gluttony it can prove fatal. While the occasional treat of a cupcake or ice-cream sundae is relatively harmless, there is an element of danger in Cotton's world, as exemplified by the cautionary tale of Hansel and Gretel.[3] The artist lures you in with his brightly colored lollipops and ribbon-candy crowns, but you linger at your own risk.

1 Adam Stennett, "Adam Stennett in conversation with Will Cotton," *Whitehot Magazine* 1 (October 2008), http://whitehotmagazine.com/articles/in-conversation-with-will-cotton/1406.

2 David Frankel, "Reviews: Will Cotton, Mary Boone Gallery," *Artforum* 47 (May 2009), 233–34.

3 Charles Darwent, "Let Them Paint Cake," *Modern Painters* (Summer 2001), 102, http://www.willcotton.com/presspageshtml/modernpainters2006.html, and Otino Corsano, "Interview with Will Cotton," Otino Corsano Blog, July 30, 2007, http://otinocorsano.blogspot.com/2007/07/interview-with-will-cotton.html.

14

JOHN CURRIN

(b. 1962, Boulder, Colorado)
Rebecca, 2001
Chalk on paper
18 × 13 3/4 in.

John Currin's work—tableaux filled with archetypal characters in exaggerated poses—has been described as modern mannerism.[1] Though his style is variously compared with that of historical masters as varied as Lucas Cranach the Elder, Sandro Botticelli, Gustave Courbet, and Norman Rockwell, Currin's combinations represent an entirely new synthesis. The artist explains that his most frequent model is himself —he paints while looking in a mirror[2]—and that he supplements his own image with figural references from 1960s soft-core girlie magazines. The women in his works often resemble his wife, the artist Rachel Feinstein, whose features he considers a paradigm of the ideal woman.[3]

Currin's technical virtuosity has earned him great recognition, but his subject matter occasionally courts controversy. He has an affinity for depicting buxom blondes, pneumatic to the point of caricature. The artist has said that he began to draw and paint women as an expression of anger—lingering resentment from an emotionally "chilly" childhood in Connecticut,[4] a lonely adolescence, and a failed college relationship.[5] When he met Rachel, however, everything changed. His fascination with women evolved from an expression of negative emotion to a preoccupation with capturing the mystery and beauty of the opposite sex. The sight of a woman can fill him with "melancholy and love and optimism,"[6] and trigger a desire to make up a story about her.

The artist's works on paper represent a vital part of his oeuvre. He sketches before and after making paintings, working out elements of style and composition, and exploring recurring topics (hobos, balloon-breasted women, domestic scenes) in experimental ways. The drawings exemplify a freedom of technique ranging from the use of transparent gouaches to cross-hatching; like the paintings, they vary in style from the traditional to the absurdly cartoonish.

Currin's unique vision of the nude—a subject as old as the Venus of Willendorf—is occasionally grotesque and often controversial, but it also offers moments of classic beauty and sweetness, as in *Rebecca*. In this small drawing, the curvaceous contours of a female form are described in scratchy chalk marks in a cool palette—subtle shades of gray against a silvery background. The headless figure resembles a classical marble sculpture in color and pose. What could be a voyeuristic delectation is instead a poetic tribute. Therein lies Currin's melancholy, love, and optimism.

1 Arthur C. Danto, "Bad Boy, Good Manners," *Nation*, February 2, 2004.
2 Ibid.
3 Jeffrey Brown, "Conversation: Painter John Currin," Art Beat, PBS News Hour video, 11:33, July 17, 2009, http://www.pbs.org/newshour/art/blog/2009/07/conversation-painter-john-currin.html.
4 Deborah Solomon, "Mr. Bodacious," *New York Times Magazine*, November 16, 2003, http://www.nytimes.com/2003/11/16/magazine/mr-bodacious.html.
5 David Kirby, "Beauty & the Bimbo," *ARTnews* 99 (May 2000), 204.
6 Ibid., 205.

WILLIAM DANIELS

(b. 1976, Brighton, England)
L'Origine du Monde, 2007
Oil on wood
7 3/4 × 10 1/2 in.

L'Origine du Monde, based on the famous 1866 painting of the same title by Gustave Courbet, synthesizes two of the most time-honored traditions of art history. Since the first cave painter put pigment to wall, artists have copied others' works, a practice that ranges in intention from study and inspiration to plagiarism and forgery as well as to the increasingly common device of appropriation. Skillful examples of the latter include Marcel Duchamp's Leonardo da Vinci, Sherrie Levine's Walker Evans and Vincent van Gogh, Deborah Kass's Andy Warhol, and Vik Muniz's everybody. Daniels brings this tradition together with that of the female nude, handled by Courbet in a way that was revolutionary for his time. Though the French realist was known to paint women in various states of undress, with varying degrees of explicitness, his *L'Origine du monde* was extreme even for him, and it retains its power to shock today. As recently as 2009, a book bearing the image on its cover was banned in Portugal for "pornographic depiction."[1]

Daniels's rendering reveals only a hint of the graphic nature of the original. He focuses instead on reinventing the female figure—this time, startlingly, in tinfoil. After choosing a source image, he meticulously replicates it as a three-dimensional collage, using found paper, cardboard, or foil. He then portrays the image in intricate detail in oil on board. Once the painting is completed, the maquette is destroyed. The results, such as *L'Origine du Monde*, are trompe-l'oeil masterpieces. Here, the brilliance of the light glinting off the aluminum in the upper right quadrant of the painting is almost blinding. The soft, pearly flesh of Courbet's model has been transmuted into pointy crinkled corners and angled folds. The illusion is so strong that one fears either crushing the delicate foil or cutting one's hand on its sharp edges. The overall luminescence of Daniels's reduced white, gray, and silver palette challenges

a reading of the work as a painting. While one can only speculate about Daniels's inspiration to recreate a famous and controversial artwork in a mundane kitchen material, it is easy to see why he was compelled to paint it: his homage is beautiful, witty, and stealthy, preserving the original's groundbreaking power to provoke.

1 Lusa, "PSP apreende livros por considerar pornográfica capa com quadro de Courbet," February 23, 2009, http://www.publico.pt/Sociedade/psp-apreende-livros-por-considerar-pornografica-capa-com-quadro-de-courbet_1366440.

16

TOMORY DODGE

(b. 1974, Denver, Colorado)
Crush, 2005
Oil on canvas
84 x 96 in.

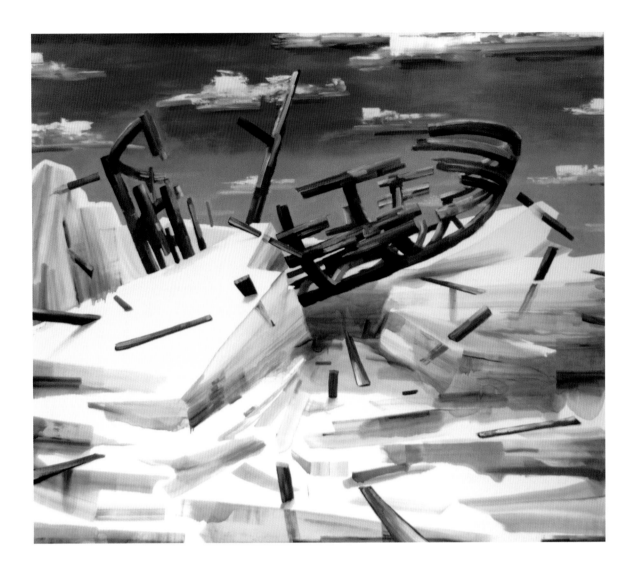

The original inspiration for **Crush** were the numerous stories of disastrous Arctic expeditions. But as with all of my paintings from this period, what really interested me most was the breaking down of recognizable forms, in a literal sense, but also in a formal way, in order to experience the interaction of material and image that seems so unique to painting.

Tomory Dodge clearly, unabashedly, loves to paint. He works and overworks the surface of his canvases, smearing on oil paint with wide brushes, palette knives, trowels, and even straight from the tube. Sometimes he pulls gobs of paint into little hills of color that reach out toward the viewer. It has been said that his central subject is paint itself.[1] When asked, the artist demurs and responds that the medium is inseparable from its subject matter, and it is the interplay between them that intrigues him.[2]

Dodge deftly walks the line between abstraction and representation. His landscapes are created with large gestural marks that seemingly could be borne away at any moment by the strength of their kinetic energy. In *Crush*, the artist presents a scene of debris and destruction that is still vibrantly alive. We can see a vessel's hull as it once was, and, exploding outward from it, fragments of itself. The icebergs, defined in wide blue and pink strokes, push upward toward a deep blue sky, cracking the once-boat as they progress. Icebergs are enigmatic menaces, concealing their true depth and volume beyond the edge of the canvas and below the surface of the water. Dodge has said that he often thinks of his marks as readymade "types" or "ideas" of brushstrokes —some are straight, some bent, some curved—and he places each one deliberately in order to build the work[3] as an architect might build a house. In *Crush*, these brushstrokes present an elegantly composed disassembling; both boat and ice are paused in the act of breaking, and soon will be no more.

Crush is strongly reminiscent of *The Sea of Ice* (1823–24) by the German Romantic Caspar David Friedrich. Friedrich's painting is a more literal depiction of ice shards, which have almost completed their destruction of a vessel. In both works, the jagged ice chunks point upward—as if thrusting their wooden prey toward heaven. In Dodge's contemporary take, the subject is treated more abstractly: wooden beams balance at impossible angles and the icebergs shift in and out of focus.

The artist is fascinated with the American cultural fixation on disaster and its aftermath of renovation and redemption.[4] This theme is a constant in his work, though what we see is always the calm after the storm. His paintings contain opposing elements, fusing depth and surface, ambition and destruction; a fatal Arctic expedition on a bright sunny day.

1 Shana Nys Dambrot, "Emerging Artists: Shana Nys Dambrot on the union of opposing forces," *Modern Painters* (February 2006), http://www.artinfo.com/modernpainters.

2 Ben Luke, "Tomory Dodge," *Art World* 1 (October–November 2007), http://wwwartworldmagazine.com.au.

3 Ibid.

4 Tomory Dodge, "Tomory Dodge," *NY Arts Magazine* (May–June 2007), http://www.nyartsmagazine.com.

PETER DOIG

(b. 1959, Edinburgh, Scotland)
Untitled, 2001
Oil on paper
15 1/2 × 22 1/4 in.

Peter Doig's paintings explore the mutability of memory and the ambiguity of perception, concerns perhaps provoked by the effects of a nomadic life. His Scottish parents moved the family from Edinburgh to Trinidad when he was two, to Montreal when he was seven, and to Toronto when he was a teenager. He left for London at age 19 to attend art school and stayed there for two decades before returning to Trinidad in 2002. Until recently he had never made artwork about the places he lived, preferring instead to rely on his memories, augmented by an eclectic assortment of visual aids including postcards, album covers, magazine clippings, film stills, and photographs taken through a telescope. Doig considers these reference materials "proxies"[1]—stand-ins for true recollections of an existent reality. He works slowly, making only six or eight paintings a year and using numerous studies and sketches to draw out a dialectic between the source and the emerging image.

Though much is made of Doig's painting from memory, the artist has frequently said he is more interested in the idea of memory itself.[2] If his images come from postcards or found objects, then whose memory is he painting and whose feelings is he expressing? The postcards and other ephemera are not only surrogates for Doig's memory but also generalized ideals of memories that anyone can send. It is possible that his deliberate nebulousness evokes a kind of collective consciousness that allows us to see our own experiences through his eyes.

Untitled exemplifies Doig's intentional ambiguity in style, form, and content. On a flattened picture plane, abstracted human and animal forms seem to be merging or disentangling from one another. The serene coloring of the work defies any sinister interpretation of the grappling. Two pale yellow figures float on a cloud of drippy gray-white brushstrokes in the middle of a buttery field punctuated by a smattering of naturalistic gray blotches in the lower left corner of the painting. These enigmatic smudges are the only elements that provide a hint of scale—they situate a sort of ground above or behind which the biomorphic forms float serenely—though they purposefully fail to establish any sort of binding narrative or spatial logic.

1 Diane Solway, "Peter Doig," *W Magazine* (November 2008), http://www.wmagazine.com/artdesign2008/11/peter doig.

2 Tim Adams, "Record Painter," *Observer* (London), January 27, 2008, http://www.guardian.co.uk/artanddesign/2008/jan/27/art.

18

PETER DOIG

(b. 1959, Edinburgh, Scotland)
Paragon, 2005
Oil on paper
23 × 19 3/4 in.

Paragon offers another kind of spatial disorientation. An earth-colored panel across the lower fifth of the painting bifurcates the image. In a literal interpretation it could be read as a wall behind which the figures stand, but it functions more abstractly as a deliberate reminder of the illusory nature of the picture plane. The saturated color in this painting is tonally balanced, giving the background, middle ground, and foreground equal value, defying an easy reading of an ordered narrative. The ensuing visual tension is the viewer's entree into the painting. When considering the subject matter, it is worth noting that in the past the artist had filmed sites that interested him by walking a few steps, filming from that spot for several minutes, then walking on a few paces, filming again, and so on, until he felt he had sufficiently captured the mise-en-scène for possible future inspiration. If we look closely at the videographers in *Paragon*, we realize that they are distinctly similar—each is a green-skinned man wearing a white shirt, facing the same way and holding a camera with two hands. When he made this painting, Doig had not used the filming method for several years, suggesting that the work may be his memory of filming and seeing, and being seen while filming, presented in the form of multiple painted stills merged into one. We do not see what the figure is recording, we see only his act of looking and capturing—the artist at work. A person or place partially recalled becomes universal, a story told by both artist and viewer. Peter Doig is an opaque raconteur.

19

STEF DRIESEN

(b. 1966, Hasselt, Belgium)
Untitled, 2006
Oil on canvas
59 1/4 × 39 1/2 in.

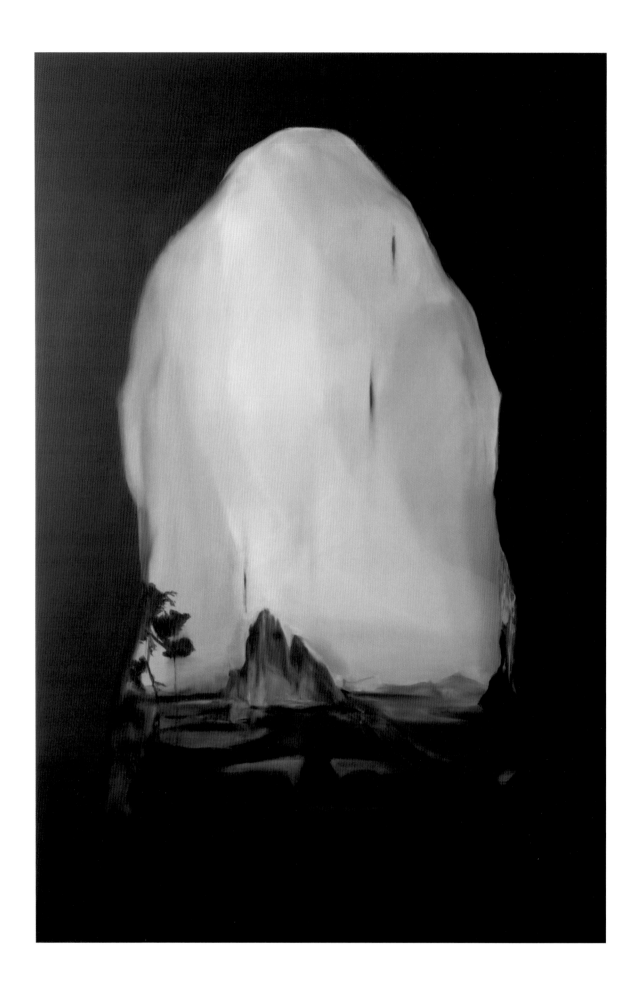

Stef Driesen's paintings synthesize human and natural forms in an emotional, romantic, and evocative way. The artist is inspired by the color palettes and compositions of Old Masters such as Peter Paul Rubens and Jan van Eyck,[1] as shown by his juxtaposition of dark colors with selective illumination, and somber, earthy charcoal grays, rusts, and muddy browns with clear, watery blues.

At first glance Driesen's subject might appear to be either landscape or the human figure, but closer inspection reveals elements of both in every painting. *Untitled* depicts what seems to be a sweeping landscape, viewed as if through a crevice, with trees, bodies of water, and jagged mountains. Eventually the ghostly white torso of a man is revealed in the pale sky above the land—an outsized Atlas towering over the suddenly diminutive earth below. An androgynous face can be made out, the head turned in profile with eyes closed. The dual perception of landscape and figure throws one's recognition of each into question. Perhaps Driesen intends to portray their intrinsic connection—as mortals we come from the earth and from nature—yet in the artist's dream-like conception there is a more ethereal force at play. *Untitled* is neither a portrait nor a landscape, but something more mythic that is left undefined.

Driesen has said that his work has an emotional basis, which may shed light on the surrealistic twists of perception intended, perhaps, to reveal an intuitive rather than a physical realm. There are many ways in which we are connected to our planet, both existentially bound to and ruling in domination over it. By reminding us of this bond, the artist sheds light on our heavy responsibility toward nature. Like all of Driesen's work, *Untitled* is somewhat eerie, with a haunting kind of beauty. The layers of perceptual awareness bring a sense of unease; the work is both a poetic tribute to the natural realm and a gentle yet urgent reminder of our place within it.

1 Jason Jules, "Soul Man: Stef Driesen," *Dazed and Confused* (December 2006), http://www.alisonjacquesgallery.com/dazed-confused-soul-stef-driesen-jason-jules-p-87.html.
2 Ibid.

20

JUDITH EISLER

(b. 1962, New York, New York)
Steve McQueen (Bullitt), 2003
Oil on canvas
48 × 60 in.

This painting is from a photo I took of the 1968 film **Bullitt**. Rather than paint an iconic and immediately recognizable image of Steve McQueen, I chose a drive-by moment where more abstract considerations define masculinity and speed. The subject is paused between an intense gaze to the left and the speed with which he will soon propel the car forward into space. The elements in the image surface only to dissolve into flares of indication.

Judith Eisler's diaphanous oil paintings present ambiguous, often unrecognizable images of famous actors and fleeting stills from well-known films or cult classics. She brings elements that are peripheral in the movies to the center of her paintings, making transitory moments her subject. In doing so, she translates the figure or story from the film into the purely visual language of painting—form and color. The ensuing perceptual gap—in *Steve McQueen (Bullitt)* between the real Steve McQueen, his macho movie-star persona, the film in which he is acting, the story it tells, and the dreamy, haunting image in Eisler's painting—is filled in by the viewer.

A movie buff,[1] Eisler spends hours watching videos on TV or her computer, including musical performances on YouTube. Once she finds a clip that intrigues her, she pauses the moving image and photographs the often faintly blurry still. Her next step, applying paint to canvas, allows for further obfuscation of the original subject. Film provides her with the element of surprise; when it is interrupted, we can see things that might otherwise go unnoticed. Eisler frequently enlarges small details so that they fill her canvas entirely: the throwaway glance or transition shot becomes a signifier bearing a constellation of allusions. The final artwork exists at a great phenomenological remove from the starting point, with meaning filtered from actor to film to editing room to movie to television monitor or computer screen to photograph to painting.

In *Steve McQueen (Bullitt)*, Eisler depicts only the back of the head of the famous anti-hero nicknamed "the King of Cool"; the sole clue that he is the renowned race-car enthusiast is that he is clearly behind the wheel. All incidental elements have been eliminated. The palette is gloomy and noirish, the scene illuminated only by a bright burst of light in the foreground that could be either headlights that appear in the movie or the artist's camera flash reflected in the still image. McQueen is identified only by the title. Outside the car there are hints of a crowd in the distance, but on closer inspection their waving arms dissolve into dark abstract forms. Whether they are a party, a riot, or completely irrelevant to Eisler's new pictorial narrative is equivocal. It is open to conjecture if this is even a portrait of the iconic Mr. McQueen at all. The figure could be anyone, anywhere, on any journey. The opacity that results from the many layers of interference and transformation in the journey from the man to the canvas enhances the act of looking rather than offering the clarity of seeing.

1 Jeffrey Kastner, "First Take, 12 New Artists: Judith Eisler," *Artforum* 42 (January 2004), 131.

INKA ESSENHIGH

(b. 1969, Bellefonte, Pennsylvania)
Spring, 2006
Oil on canvas
72 × 62 in.

In this work, I wanted to show spring as if it had come instantaneously, and show the movement of growth. It's happening as the person who is still wearing a winter jacket walks through the landscape.

Though Inka Essenhigh's work has been compared with that of artists from Francis Bacon to Salvador Dalí and Walt Disney,[1] the phantasmagorical and seductive alternate reality of her half-alien world is entirely her own.

The daughter of an English father and Ukrainian mother, Essenhigh grew up in a suburb of Columbus, Ohio, where she identified as American despite attending a Ukrainian school and summer camp.[2] Her parents encouraged her interest in art from an early age—she made small copies of Michelangelo's paintings as a child.[3] Among the jobs she held before achieving artistic success, one directly inspired the work she makes today. Working as a designer of low-end fabric for men's boxer shorts for Sears, she observed that a repetitious pattern—a golfer floating on a neutral background, swinging a club—could be seen as telling a story. The golfer appears over and over again, never hitting the ball—a tale of frustration. Essenhigh was struck by the idea that in this kind of visual narrative, people are what they are doing. She has credited this recognition with the evolution of her work from a more abstract expressionist style to the enigmatic scenes she paints today.

Her working method is experiential: she starts with color and lets the content emerge. A white canvas might suggest a snow scene while a black one could evoke outer space; the first marks she makes might turn into flowers or into demons. A number of paintings feature beings—some almost recognizable as human, others amorphous serpentine creatures—pulled by strings or forces apparently beyond their control. Other creations proudly take charge of their destiny, as in *Spring*, where a bendy humanoid strides

confidently through what resembles an underwater forest of tropical florae. Both figure and viewer are transported into a fairy-tale land. In more vaguely threatening works, beings grapple heavily with each other against ominous dark backgrounds, disquietingly depicted in cartoonish swooshes and swells.

It is tempting to imagine that in *Spring* we are glimpsing something of Essenhigh's psyche—the artist as intrepid traveler in a strange land. An alternate understanding might be that we do not know where this land is, or who inhabits it. A narrative is present, but fantastical. We have never seen this brave new world, that has such creatures in it.

1 Yannis Tsitsovits, "Inka Essenhigh," *Stimulus Magazine* 17 (April 2007), http://issuu.com/stimulusrespond/docs/stimulus17.
2 Hilarie M. Sheets, "Swirls, Whirls & Mermaid Girls," *ARTnews* 103 (May 2004), 137.
3 Ibid.

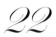

BRIAN FAHLSTROM

(b. 1978, Kansas City, Missouri)
Reflected, 2006
Oil on canvas
76 1/4 × 83 1/4 in.

I paint always remembering that it is a physical act producing physical results. Moving pigment across the surface of a canvas is the way for me to articulate complex thoughts and feelings.

Although Brian Fahlstrom's paintings could be classified as abstract, an element of representation seems to lurk beneath their multilayered surfaces. While forms may be hinted at, they never quite coalesce, emphasizing the artist's focus on the unknowable aspects of painting. A nonverbal medium, painting is open to subjective interpretation by both viewer and creator. *Reflected* may be enigmatic, even entropic, but this does not imply any shortage of content. Great swirls of gestural color swoop across a large canvas, carrying our gaze high into a windy sky over a peaked mountain range or deep beneath a sea into an underwater world of eddies and shifting half-animate forms—or both, or neither. The suggestion of recognizable form in *Reflected* represents a departure from Fahlstrom's earlier, flatter color-field-style paintings. The shift took place when the artist realized what he saw and how he felt when he looked at his work. He saw landscapes[1] and had powerful emotional reactions to them. From that point on, he painted what he saw inside the canvas, allowing each brushstroke to reveal the worlds and the sentiments contained within it.

Fahlstrom's work is often described as painterly, but while accurately describing his deft use of color, movement, and open-ended form, this characterization tells only part of the story. Things are not what they appear to be, and reliance on our lived experience won't help us much to explain what is going on—we just have to feel it and allow our intuition to guide the way. His paintings depict an imaginary world, or a new world that hasn't yet been invented.

1 Chris Balaschak, "Brian Fahlstrom at MARC FOXX," *Frieze Magazine* 105 (March 2007), http://www.frieze.com/issue/review/brian fahlstrom.

23

ERIC FISCHL

(b. 1948, New York, New York)
*Krefeld Project, Sunroom, Scene #2
(Champagne)*, 2002–03
Oil on canvas
36 × 54 in.

Eric Fischl is a self-described idealist who believes in the power of paint. He seeks to make paintings that feel alive and that draw in the viewer through, in his words, "a seduction."[1] It is not surprising that the artist uses a word that connotes corporality, for his work is infused with a relentless physicality that surpasses even that of the fleshy, muscular bodies that inhabit it.

Fischl makes paintings, drawings, prints, sculptures, and photographs. His photography serves as raw material for digitally composed collages that he later executes in paint. Before the invention of Photoshop, the artist drew on layers of glassine and tracing paper, moving images around to perfect his compositions before putting paintbrush to canvas.

The Krefeld Project was commissioned by the Museum Haus Esters in Krefeld, Germany, which was designed as a residence by Mies van der Rohe in 1928. Fischl furnished the house in a modern style and hired a male and a female actor to "live" there, giving them ambiguous "problems" to portray ("she wants to borrow money from him, but won't say why"). He took several thousand photographs of the actors over four days while many unscripted relational melodramas played out. Though Fischl speaks no German and the actors no English, the dynamic communicated by their body language and verbal expression was so riveting that the artist had to struggle to remember to take photographs.[2] The man and the woman enacted all aspects of daily life in scenes ranging from the intimate to the mundane: in various stages of dress and undress they bathed, shaved, and made love. In Krefeld Project, Sunroom, Scene #2 (Champagne), the two are either dressing to go out or have just returned from an evening's revelry. Like a film still, this work captures an in-between moment, the kind of experience one has but never sees.

The fictional struggles of the pair became so real for Fischl that when he returned to New York to paint from his photographs he was caught up in their problems and it was often upsetting for him to go to his studio. He felt guilty for engineering scenarios that could result in even fictitious human suffering.[3] His emotionally fraught experience spilled onto his canvases, expressing ambiguous and ambivalent human needs and desires, connection and isolation. Each painting in this series is charged with the weight of communicating more than it reveals. Fischl deliberately leaves his narratives vague—implied, not imposed. He prefers to invite the viewer to participate. The artist paints figures in contemporary times so that his audience can relate to what they see. Even if, as Fischl puts it, there is "bad stuff" there, it is never impossible to recover.[4] His delicate ambiguity is not about alienation but instead represents a heartfelt desire to connect.

1 Arne Glimcher, "The Artist's Studio: Eric Fischl," Plum TV, Arts & Entertainment video, 21:30, May 14, 2009, http://www.plumtv.com/videos/artists-studio-eric-fischl/index.html.
2 "The Figure in Narrative," Eric Fischl interviewed by A. M. Homes, "BOMBLive!," New York Academy of Art, New York, October 26, 2005, http://bombsite.com/issues/999/articles/3251.
3 Ibid.
4 Glimcher, "Artist's Studio."

LOUISE FISHMAN

(b. 1939, Philadelphia, Pennsylvania)
Loose Change, 2005
Oil on canvas
60 × 55 in.

Loose Change was the last painting I made for my Cheim & Read show in 2006. It signaled a desire to simplify and to make paintings as fresh as they could be. The title reflects the ease with which it was painted—like feeling the coins in one's pocket.

For four decades Louise Fishman has explored both personal and political issues in her work while continuously examining and renewing her practice. Growing up in Philadelphia, she discovered art at an early age, leafing through her painter-mother's *ARTnews* magazines.[1] In the mid-1950s she began painting in oil while studying at the Philadelphia College of Art. Her early work was known for its gridlike compositions —strong vertical and horizontal impulses that never disappeared but emerged in different iterations over time. By the 1970s she was involved with the feminist movement[2] and made mixed media and sculptural work using craftlike methods such as sewing and other "women's work," but she soon returned exclusively to painting. Fishman's engagement with history and social justice led her to political activism and to the exploration of her own identity through art making. A haunting trip to concentration camps in Europe in 1988 influenced her profoundly; she returned home with silt from the Pond of Ashes in Auschwitz and alchemically mixed it into her paint.[3] The resulting dark and eerie series is titled *Remembrance and Renewal.*

Much critical attention has been paid to Fishman's athletic wielding of large brushes[4] and seemingly boundless energy. At some points in her career she struggled with the intersection of cerebral and intuitive ways of working as she found herself engaged in strenuous cycles of painting, sanding, trowelling on more paint, and sanding again. She uses both large and small canvases, working on up to four or five at a time. Although she does not intentionally set out to work in series, this process often results in paintings emerging in groups.

Loose Change is a gestural celebration—a torrent of colors and freestyle swaths that whistle across the canvas like the wind. On close inspection we can see the vertical impetus in the background of the painting, but it is overwhelmed by the curvilinear marks that slide horizontally through the composition. The earthy backdrop is upstaged by the primary colors at the painting's surface. Though Fishman's workmanship is evident in every brushstroke, the title reinforces the overall sense of easy lightness, like a cold drink on a hot summer night.

1 Edward M. Gomez, "An Abstractionist Maintains the Faith in a Skeptical Era," *New York Times,* September 17, 2000.

2 Ibid.

3 Joe Fyfe, "Louise Fishman at Cheim & Read," artcritical, April 18, 2009, http:/ artcritical.com.

4 Nancy Princenthal, "Louise Fishman at Cheim & Read," *Art in America* 94 (May 2006), 182.

25

LARS FISK

(b. 1970, Norwich, Vermont)
Trashbags, 2008
Marble
63 x 58 x 46 in.

This sculpture, carved traditionally from a block of marble, represents the piles of waste that are common in New York streets. It is also meant to refer to classical Greek statuary, with specific attention to the folds of drapery that are rendered here in the crinkle of plastic.

Lars Fisk may be known to some of the millions of fans of the band Phish as the innovative artistic director who created the group's unique stage presence from 1996 to 2005, building a giant aquarium stage set or having the musicians perform on trampolines for audiences of up to 80,000.[1] His own art, on a more modest scale but equally original, is about considering everyday objects and the world around us in a new way.

A past series, *Spheres*, consists of objects such as a Volkswagen, a tractor, a barn, a street, a UPS truck, a school bus, and a Mr. Softee ice-cream truck rendered as perfectly round balls, complete with windows, steering wheels, headlights, logos, and, in the case of the street, a dotted yellow line. About his newest body of work, Fisk has said, half-jokingly, "I'm kind of into the trash thing right now."[2] This theme is evident in his dented metal trashcans, discarded coffee cups, and garbage bags, all made of masterfully carved marble. In *Trash Bags*, Fisk has meticulously carved a life-size pile of seven heavy-duty twist-tie trash bags out of a single piece of black marble. The sculpture functions as a trompe l'oeil object, startling the viewer by appearing to be a pile of waste placed in the pristine setting of an art gallery or museum. By imagining refuse as immutable, Fisk asks us to reconsider issues of permanence with respect to human consumption. Does our planet's waste ever really go away, or is it with us for eternity?

1 Trey Anastasio, "Lars Fisk—2007 Studio Manager & Working Resident," http://www.treyanastasio.com/nonprofit/artistresidence.html.
2 Thomas Weaver, "Artists at Work," *Vermont Quarterly* (Fall 2006), 20.

CAIO FONSECA

(b. 1959, New York, New York)
Pietrasanta C01.33, 2001
Mixed media on canvas
53 x 72 in.

When asked about the meaning of his work, Caio Fonseca has quipped that "no one ever asked Bach what he meant."[1] Fonseca is interested in the subject of painting itself—the relationships among the colors, tones, forms, contrasts, and proportions that make up each work. For him, a painting is successful when these elements coalesce to generate a singular energy. When this state of dynamism is achieved, the work is finished, and can speak for itself in its own language.[2]

Fonseca was born into a creative family who nurtured his talent for art and music from an early age. His artistic education was old-world, including a five-year tutelage under the prominent Uruguayan painter Augusto Torres in Barcelona. He spent most of his 20s in Europe visiting museums and studying the great masters. He learned how to draw and paint figuratively, but as his own style evolved he began to look less and less at the model or still life and more and more at the canvas itself. This change of perspective was the catalyst that led him to his current abstract style. Reflecting on this exploration, Fonseca believes that the crux was the discovery of abstraction in nature and in the visual world around him.[3]

Fonseca's working method is disciplined almost to the point of asceticism. He spends six months a year working alone in his studio in Pietrasanta, in northern Tuscany. He does not make preliminary sketches for paintings, but marks the canvas in charcoal where forms and shapes might later appear. Next, he sits in a chair about 10 feet from the work and contemplates the almost blank canvas. During this long period of examination, forms suggest themselves, allowing the first layer of the work to begin to materialize. This underpainting, which often consists of beautifully colored geometric shapes, lines, and curves, is extremely important to him, though it is often almost completely concealed in the finished work.[4] The next step is a deliberate obscuring of the colorful forms by layers of paint, the relation between them made clear by their very obfuscation. The contradictory process of adding images

and immediately subtracting them is almost perverse, yet it achieves uniformly successful results. Explaining his process, the artist draws a comparison between painting and writing: his method, he says, is akin to that of a writer putting down the entire English language on paper and then removing words to find the story.[5] Fonseca is ambidextrous; he uses whichever hand is closer to the side of the painting he is working on. Finally, he inscribes the surface with an unusual assortment of tools, from dental equipment to tuning forks and kitchen utensils. These lines delineate the relation of one shape to another, helping the viewer make visual connections between them.

Pietrasanta C01.33 is an archetypal example of the subtle force generated by this simultaneous revealing and concealing, adding and subtracting, working and overworking. The creamy butter-colored surface obscures grass-green, lemon-yellow, and pale gray shapes. The face of the painting is lightly scratched with diagonal lines that stretch from one side of the canvas to the other, aligning one shape with a seemingly separate one. Even without knowing the artist's process, one can immediately perceive the correlations between the geometric lines and the forms in the underpainting. These connections serve the artist's goal of evoking the world without imitating it. With *Pietrasanta C01.33* Fonseca shows that the visual language of a work can be eloquent enough that no verbal explanation is necessary.

1 Valerie Gladstone, "Strokes of Genius," *Departures Magazine*, September 2004, http://www.departures.com/articles/strokes-of-genius.
2 Nancy Bagley, "An Artist's Way," *Washington Life Magazine*, November 2004, http://www.washingtonlife.com/issues/2004-11/verbatim/index.html.
3 Conversation with the author, October 21, 2010.
4 Karen Wright, *Inventions: Recent Paintings by Caio Fonseca* (Washington, D.C.: Corcoran Gallery of Art, 2005), 28.
5 Conversation with the author, October 21, 2010.

27

MARK FRANCIS

(b. 1962, Newtownards, Northern Ireland)
Primitive 3, 2003
Oil on canvas
84 × 72 in.

This series of open dot paintings are primarily abstract. The forms within the paintings allude to many things, such as relationships, viruses, spores, and migration. With **Primitive 3**, the forms touch and separate, hinting at notions of intimacy and isolation. Like an organized chaos or a scattering matrix.

Mark Francis's fascination with biology, cosmology, botany, and mycology directly influences his abstract paintings, monoprints, and works on paper. He grew up in the countryside, in Newtownards, County Down, in Northern Ireland. He has childhood memories of playing in rock pools and discovering birds' nests in fields, which awakened in him a sense of wonder at the natural world.[1] At school he studied both biology and art until he had to choose between them.[2] Although art became his vocation, he has never abandoned his investigation into the life cycles of organic matter, from fertilization and mitosis to death, decay, and renewal. Medical and scientific imagery from his continuing studies joins his early memories of nature and informs his art. He does not work from photographs or illustrations directly, but images from nature and life studies filter through his imagination and emerge as biomorphic abstractions.

Francis's early paintings resemble landscapes, with a horizon line and other spatial cues to orient the viewer. He soon began to explore a broader field of vision, one that required either a telescope or microscope. Despite his interest in astronomy,[3] his work more frequently references an internal biological landscape, dramatically enlarged. Over the years he has evoked imagery of sperm, ova, mold, spores, fungi, and other microorganisms. Though he refers to intermittently discernible phenomena, his process is intuitive and experimental. He leaves ample room for chance and accident.

Primitive 3 depicts a random pattern of lightly smudged blood-red circles floating across an orange background. Francis uses two methods to make the forms simultaneously blend into and separate from the color field. His practice of brushing over his canvases with vertical and horizontal strokes while the paint is still wet leaves faint trails behind the red forms, as though they were propelled into motion. A combination of matte and gloss surfaces makes the forms stand out even more—they are opaque, while the remainder of the canvas has a subtle luster. We could be seeing the daily miracle of cell division, botanical spores, or a brilliantly colorized view of tightly clustered constellations. The artist has revealed that his interest in biology is driven by a desire to seek answers to "the big questions," such as, Why are we here?[4] It is evident in his artwork that it is possible to explore these questions with a paintbrush as well as in a lab.

1 Richard Dyer, Francis McKee, James Peto, *Mark Francis* (Dublin: Dublin City Gallery, The Hugh Lane, and Lund Humphries, 2008), 15.
2 Ibid.
3 Ibid., 22–24.
4 Christian Kuras and Duncan MacKenzie, "Episode 197: Mark Francis," Bad at Sports: Contemporary Art Talk audio, 53:29, July 7, 2009, http://badatsports.com/2009/episode-197-mark-francis.

BERNARD FRIZE

(b. 1949, Saint-Mandé, France)
Opry, 2000
Acrylic and resin on canvas
88 × 72 in.

There is no equivalence between painting and language, otherwise it would have been verbalized. It's about a whole bundle of things that are conveyed in the actual experience of the painting. A painting is an incredible object: it's flat, facing you, you stand facing it—I mean, it's an incredible moment that catalyzes emotions, unusual sensations, and this moment is conducted through materiality.

Bernard Frize aims to radically demystify painting. He works according to a strict set of rules within a system that he keeps changing. Once he has acquired the skills necessary to master a particular technical challenge he has assigned himself, he changes the game and starts again. This method results in distinct series within which works may closely resemble each other in design if not in color. The rules are always evolving, however, and the patterns may look nothing alike from one series to another. Frize has succeeded in almost entirely associating the content of his work with the process by which it is made—a process that he deems evident in every finished artwork he exhibits.[1] He wishes to omit all elements of choice or expression from his works through the imposition of external constraints such as a strictly limited or unlimited palette and a focus on his materials (paint, brush, canvas) as tools.

Each new series is a challenge. In the past, he has arranged on canvas all the dried skins of paint that have successively formed in open paint cans; painted blindfolded while directed by someone else; covered a large canvas with marks made by an incongruously tiny brush. The idea of painting-as-game is so ingrained in the artist that he often overtly references games such as chess, checkers, and solitaire. He frequently works with a team of assistants to execute patterns that could not be made by one person alone; the brush is handed from one to the next as the painting progresses. The idea is to create one continuous line, or a series of interwoven lines, without ever losing contact with the surface. Once the artist establishes the rules and maps out the composition (using a graphic computer program followed by pencil marks on the

canvas), he and his team paint quickly. They are not allowed to go back or to correct marks that have been made; as Frize says, "to retouch is already to cheat."[2] More than just a game, this method represents Frize's quest to remove the artist's hand from the process—or at least to make it one of many hands—and to introduce the element of chance. He goes to great lengths to avoid personal decision making that might interfere with the predetermined plan, and chooses colors at random to avoid interjecting his own preferences. Ironically, his use of every color of the rainbow could be construed as a signature style.

Opry is a striking example of Frize's intricate systems. The bright colors begin at the top of the canvas and snake their way down to the base in a braidlike coil of diminishing color and muddying palette. Light pencil marks appear on the surface where the artist mapped out the looping shape on the white background. The painting was planned ahead of time, and only in its execution did things go slightly off kilter. In the interest of transparency, Frize allowed the marks to stay, so we can see how the work is made and speculate about the rules of the game. To erase them would be cheating.

1 Jens Hoffmann, *Bernard Frize: Longues lignes (souvent fermées)* (London: Simon Lee Gallery; Paris and Miami: Galerie Emmanuel Perrotin, 2007), 8.
2 Ibid.

GOTTHARD GRAUBNER

(b. 1930, Erlbach, Germany)
domino III, 2001
Oil and acrylic on canvas on synthetic
16 3/4 × 16 1/4 in.

In the small monumental, in the big intimate.

Gotthard Graubner's single-minded and ambitious aim is to elicit a pure sensory-perceptual experience of color.[1] He grew up in the German countryside under the shadow of World War II, and his earliest preoccupation was a search for meaning and identity both for himself and the natural world during a period of turmoil.[2] His formative memories are of forays into the forests and fields surrounding his home, where he climbed trees and got caught in rainstorms, and gained a lifelong interest in biological creation and organic growth.[3] The recognition of nature as a creative process, along with Graubner's artistic exploration, ignited a belief that the methodology of art making is a natural one and must be embraced and experienced as such.[4]

Graubner's method is both deliberate and intuitive. He makes no plans or sketches for his paintings. Each work begins as a tightly stretched canvas lying flat on the studio floor, which he builds up with synthetic padding and multiple layers of canvas, rounding off the corners and creating a pneumatic pillowlike shape. He uses a variety of brushes (some of his own making) to saturate the canvas with color from inks, powders, oils, or acrylics. The painting remains on the floor and the artist moves around it, circling repeatedly as he pours, brushes, rolls, and washes color in layer after layer until he deems the work complete. The buildup of canvas, padding, and color creates three-dimensionality and introduces variations in color and tone that often come together in what the artist refers to as the painting's "navel."[5] This corporeal reference is the closest we ever come to an explanation of the artist's choice of color as subject. He sees color the way a non-artist might see people, animals, or nature. It has been speculated that the rounded shapes of Graubner's works might be a reference to the female form[6]—a suggestion he neither explicitly confirms nor denies. His work demonstrates the symbiotic interdependence of color, content, and form. Titles for works are often an afterthought, meant to be read only as hints or ideas, not as clues to content or interpretation.

domino III is part of a series Graubner titled Farbraumkörper— a word he invented meaning "color-space-body."[7] The works in this series, varying widely in color scheme, are united by an illusory softness. They can elicit a powerful response in the viewer, evoking the fading light of an autumn sunset, a cloudy day just before a storm, or the depths of the ocean.

1 "Farbraumkorper (Color Space Bodies) and Works on Paper," Neues Museum Weserburg, Bremen, Germany, http://www.weserburg.de/index.php?id=234&L=1.

2 Max Imdahl, Volker Kahmen, and Hans Albert Peters, Gotthard Graubner (Baden-Baden: Staatliche Kunsthalle Baden-Baden; Düsseldorf: Kunstmuseum Düsseldorf, 1982), 239.

3 Ibid., 240.

4 Ibid., 241.

5 Jorn Merkert, "Distance and Nearness," Gotthard Graubner: Malerei aus den Jahren 1984 bis 1986 (Düsseldorf: Kunstsammlung Nordrhein-Westfalen, 1987), 54.

6 Ibid.

7 Max Imdahl, Volker Kahmen, and Hans Albert Peters, Gotthard Graubner (New Delhi: Fifth Triennial–India, 1982), 13.

30

MARC HANDELMAN

(b. 1975, Santa Clara, California)
Tomorrow's Forecast: Strikingly Clear, 2007
Oil on canvas
69 × 69 in.

My work has largely explored questions around the correspondences between aesthetics and power, situating and drawing out the space of painting as both a catalyst and antagonism within a regime of the image. With the work comprising **Tomorrow's Forecast: Strikingly Clear**, I attempted to re-frame the exhibition space, playing out the theatrical veneers of the corporate lobby and the increasingly "interactive" displays of multimedia advertising. The individual paintings functioned cyclicly as dark slabs of marble, entropic ruins of the screen, and flashes of light from abstracted fragments of a logo. I was interested in a space that was at once romantic-spectacle, illusory, seductive, and yet anti-transcendent—literal, perverse-material-effect, trope, and theatre. I like things that create a real conflict for myself and the viewer, as opposed to entanglements that presuppose critical if tidy resolutions.

Marc Handelman examines the military-industrial complex, the neo-liberal ideologies of the last decade, proto-Fascist aesthetics, and the saccharine "art" of Thomas Kinkade with equal dexterity, intelligence, and what could be construed as wit if the artist weren't deadly serious. His source material— one hesitates to refer to most of it as inspiration—ranges from the heroic paintings of the Hudson River School, particularly Frederic Edwin Church, to billboard advertisements and corporate logos, the defense contractor Northrop Grumman, the work of Leni Reifenstahl, and the totalitarian architecture and theories of Albert Speer.

Tomorrow's Forecast: Strikingly Clear expresses Handelman's preoccupation with the intersection of beauty and power and the potential fallout caused by their seductive deployment —exploitation and destruction. He has long been fascinated by apocalyptic themes, particularly that of a nuclear winter brought about by the arms race and its proponents. Much of his work plays on a concept introduced by Speer (whom he reviles) of "ruin value"—the idea that architects should build things that will remain aesthetically compelling and evoke the might of their civilization as ruins, long after the society for which they were created has crumbled into history. In this artwork, Handelman depicts a veiled, translucent letter-form that is part of the logo for Northrop Grumman, the fourth largest defense contractor in the world,[1] specializing in nuclear submarines, strategic bombers, aerial surveillance, and other forms of weaponry. The company has a highly controversial record on environmental pollution and issues of national security.

In *Tomorrow's Forecast: Strikingly Clear,* it seems that some of this malfeasance has come back to haunt not only the alleged perpetrators but also the innocent. Dark drips of blue-black paint slide ominously down the surface. The logo of the company hired to defend us has fallen upside down, and, though still glowing faintly as if in a crepuscular dawn, appears to be disintegrating. The simplified black-and-blue palette evokes the monochromatic view through night-vision goggles—also manufactured by Northrop Grumman. While it is possible to view this work as entirely pessimistic, its magnetism and poignancy bely this reading. At the end of the world, there is a kind of heroic beauty, and with it a hope for new life. Handelman's work is not a prediction of an inevitable future, but an inspiration to do better and an uneasy call to action.

1 "BAE Systems No. 1 in global arms sales in 2008, says SIPRI," Stockholm International Peace Research Institute, press release, April 12, 2010, http://www. sipri.org/media/pressreleases/100412top100.

31

MARY HEILMANN

(b. 1940, San Francisco, California)
Broken, 2005
Oil on canvas
42 × 29 in.

Broken is a piece from 2005. All of these pieces that have a black-and-white checkerboard motif with red cuts, and often spills of red, refer to an autobiographical event, the sad end of a relationship. A breakup, hence, the title **Broken**.

Mary Heilmann crosses the territorial divide between modernist formal abstraction and the depiction of personal experience. Her inspirations include an eclectic range of musical tastes (Bob Dylan, the Sex Pistols, Drum & Bass), the rough-hewn naturalistic Japanese ceramic style known as *wabi-sabi*, the TV show *The Simpsons*, and her own biography. Often some or all of these diverse influences collide in one work. Heilmann grew up in California between the beatnik and hippie eras and studied literature and ceramics, as well as (briefly) painting under David Hockney, at the University of California, Berkeley. Painting was out of fashion among her set at the time, and she worked exclusively in mixed media sculpture. On moving to New York in 1968 as an ambitious young sculptor, she sought out established artists such as Richard Serra, Robert Smithson, and Bruce Nauman. Finding her reception cool and her sculpture underappreciated, she defiantly took up painting, a medium that was flagging commercially and looked down on by the "boys club."[1] Heilmann has since continued to break all the rules. In addition to her auspicious foray into painting, she returned to ceramics and furniture, often placing her chairs in exhibition spaces so that viewers could sit down and contemplate her work, chat, and enjoy the sense of community she has always sought.

In *Broken*, Heilmann appropriates the universal geometric forms of squares, grids, and quadrilaterals in a knowingly casual way. The edges of the black, red, and white squares drip and swell into each other, and there are visible brushstrokes and evidence of mark making throughout. Her background in sculpture informs her paint handling, generating a three-dimensionality that lurks beneath or hovers above her surfaces. This effect is reinforced by her practice of painting the edges of her canvases, contesting the picture's two-dimensional plane and stating its objecthood. Her working method is one of careful mapping—she uses graphic programs on her computer to work out ideas of form, color, and composition before putting paint to canvas. In the tessellated yet rich painterly surface of *Broken*, she articulates her personal story not as a literal pictorial rendering but as an abstraction of her thoughts and feelings at a moment in time.

1 Terry R. Myers, "Heil Mary," *Modern Painters* (April 2007), 75.

32

SHIRAZEH HOUSHIARY

(b. 1955, Shiraz, Iran)
Fleck, 2005
Blue pencil on white Aquacryl on canvas
27 1/2 × 27 1/2 in.

What matters is what cannot be seen and the ceaseless energy and rhythm within things.

Shirazeh Houshiary makes art about breathing.[1] For her, the act is symbolic of life itself, with all its unknowable variations, transitions, and fleeting moments of perceptual epiphany. Born in Iran, she is versed in Sufi mysticism and it informs her work extensively.[2] Now living in London, she rejects the ghettoizing stereotypes of "Western" versus "Eastern" art traditions, and has recently designed a stained glass window for the church of St. Martin in the Fields. Her visual investigation into the limits of human knowledge and understanding aims to transcend contextual forces such as culture, nationality, and gender.

Houshiary's art-making practice is solitary and deliberate. She works in silence until the work is almost complete, at which point she listens to music and channels the vibrations of the sound into the rhythm of the image. It can take her two to three months to complete a single work. Painting only on square canvases, chosen for their simplicity and uncomplicated perfection,[3] she places them on the floor and leans over them, moving around and around the edges until the composition is complete. The painting begins with an Arabic word that she writes over and over again in an intricate circular pattern flowing out from a central point. The script is eventually veiled by this layering process, which she compares to burying a thread within a piece of cloth. The word is only a starting point—the first breath—of the exploration. She never reveals it, in order to avoid triggering any direct cognition that would distract from the experience of contemplation.

Like most of Houshiary's oeuvre, *Fleck* has a deliberately ambiguous title. The white background is typical; she uses either black or white fields because for her they represent infinity and boundlessness.[4] The white Aquacryl here provides a flat finish with barely distinguishable pores. The palette is that of a daytime sky in reverse—a blue cloudlike formation floats on a white background. The orbiting motion of the blue-on-blue script is so subtle as to be almost invisible, an effect perhaps related to the artist's interest in particle physics, particularly the idea that solidity is an illusion generated by the movement of subatomic particles, discernible with only the most powerful microscopic technology. Houshiary is entranced by the notion that if you dig deep enough, all binary thinking is voided and the connections between things are revealed.

1 Eleanor Heartney, "Shirazeh Houshiary at Lehmann Maupin," *Art in America* 92 (April 2004), 130.
2 Jeffrey Kastner, "Shirazeh Houshiary: Lehmann Maupin," *Artforum* 42 (January 2004), 155.
3 Anne Barclay Morgan, "A Conversation with Shirazeh Houshiary: From Form to Formlessness," *Sculpture* 19 (July/August 2000), 25.
4 Ibid., 26.

33

JACQUELINE HUMPHRIES

(b. 1960, New Orleans, Louisiana)
No Fun, 2007
Oil and enamel on linen
90 x 96 in.

No Fun is one of four large paintings I painted as a group and which I showed in London at Stuart Shave / Modern Art. It is the largest and most complicated of the four. Normally I work on a whole painting at a time. In other words, any area or all areas of a painting are game for reworking. I might alter a large part in the lower left quadrant, which leads to reworking in some other area of the painting. Or what often happens is the whole painting gets painted over. In the case of **No Fun**, the upper half was complete and yet would not integrate with the bottom, which left me with repainting the bottom half, which I did countless times. That top half, it seemed to me, would not come out to play, and that is how **No Fun** earned its title.

Jacqueline Humphries has said that she paints to "engage one in a kind of dramatic physical event."[1] Her subjects are light and space, and movement her most powerful tool. She has experimented extensively with illumination, sometimes using light boxes and black lights to create installation-style environments within which her work can be experienced. She subverts perspective through her frequent use of mirror-like backgrounds. The confluence of color, shape, and linear elements shifts as the viewer walks around her paintings: forms that clearly coalesce at one point shimmer apart when viewed from another angle. This is exactly the kind of "dramatic physical event" she seeks to elicit.

Humphries often uses canvases that are over seven feet high or wide, and has long been fascinated by signs and billboards, especially the empty ones often seen along highways. She has commented that these would offer excellent opportunities for guerrilla-style painting.[2] Another of Humphries's ongoing preoccupations is the luminescence of television, movie, or computer screens, an effect she channels into her elegant illusory works, made with everything from large paintbrushes to spray paint and masking tape. One can almost see the flicker.

In *No Fun*, Humphries allows form and formlessness to coexist. From one perspective it resembles an aerial view from a satellite, from another it could be a tessellated TV screen caught at the moment when the cable goes out. There are strong vertical and horizontal lines both over and under more painterly gestural elements, as though dividing the painting into different planes. This off-kilter structural layering, the quasi-transparent blue and silver tones, and the overall effect of pictorial disorientation are like falling down a waterfall inside a computer, throwing the viewer into a heightened state of perceptual awareness.

1 Quoted in Johanna Burton, "Jacqueline Humphries," *Artforum* 45 (February 2007), 292.
2 "A Conversation: Erik Neil, Jacqueline Humphries, and Tony Oursler," http://jacquelinehumphries.net/welcome/welcome.html.

BRYAN HUNT

(b. 1947, Terre Haute, Indiana)
Flume I, 2006
Cast aluminum
130 x 36 x 36 in.

Flume l is a conduit, a connection between heaven and earth,
an act of nature, it alludes to something majestic like a waterfall, a geyser,
an avalanche or lava flow.

Something so grand that it quiets the soul, and humbles human scale.
Flume l is about soaring and freedom and imagination, it is an abstract form
that is in transformative flux as one moves around it.
For me this sculpture speaks of purpose and beauty.

Bryan Hunt is inspired by the power of nature and the almost equally impressive human mastery of aeronautics. Born in Terre Haute, Indiana, he spent many happy childhood days exploring the outdoors. When he was 10, his family moved to Tampa, Florida, where the shuttle launches from nearby Cape Canaveral's Kennedy Space Center loomed large in his elementary school education. He eventually got a job at the Center, first delivering mail and the following year as an engineer's aide. Hunt was fascinated by what he learned, most importantly that after shuttles take flight vertically they eventually orbit the planet horizontally—flight is essentially three-dimensional.[1]

The artist expresses his interest in physics, geography, and engineering by exploring subject matter such as airships, dams, lakes, and waterfalls. He allows the subject to dictate the medium—he has worked in materials as varied as fiberglass, balsa wood, bronze, metal, and iron. He is also a prolific draftsman and painter, and often develops initial ideas for his sculptures on paper. To create *Flume I*, Hunt first made sketches and then a full-scale clay model that he used to cast the finished work.

A "flume" is a natural gorge through which water may flow, an artificial waterway serving as a chute to transport items, or, in hydraulics, a channel used to study the effect of gravity on the flow of liquids. This malleable concept of a device that facilitates motion is a typically opaque starting point for Hunt.

Instead of abstracting a representable image, he transforms an abstract idea into something more figural and evocative. In *Flume I*, the gorge itself is absent, but the flow of water is implied by the motion embodied in the form. The nearly 11-foot-high sculpture twists and turns as though pulled by an eddy or undertow. The curvilinear shape gently insinuates a female form; it could almost be a Gaia totem. The artist's hand is visible everywhere—we can see where his fingers have kneaded the clay into bubbles and ripples. The silver patina creates the effect of light reflecting off the surface of water, as in a moving stream or a breaking wave. The final syncretic touch is Hunt's decision to cast this work in aluminum—a molten medium for a liquid subject.[2]

1 Phyllis Tuchman, "Bryan Hunt's Balancing Act," *ARTnews* 84 (October 1985), 66.
2 Ibid., 65.

35

BILL JENSEN

(b. 1945, Minneapolis, Minnesota)
Ashes, 2004–06
Oil on linen
49 × 38 in.

Ashes themselves represent loss. One substance has been changed, transformed through an intense physical natural phenomena, fire. What is left is ash. Ash is very beautiful, very tactile, very sculptural, but when you touch it you realize that nothing is there.

In the painting **Ashes** you see space, then at next glance space does not exist. You see activity, agitation, then you see calm. You see images, substance, then you see emptiness. It is energy becoming, then not becoming. Substance in a constant state of transformation.

Ashes the substance and **Ashes** the painting both have a clear understanding of death.

Death, the transformation of energy, the loss of energy near to nothing.

Bill Jensen believes that it is the mission of every artist to act as a vessel through which greater phenomena of nature and the all-encompassing life force may flow.[1] He is interested in Chinese art and philosophy, particularly Taoism's tenets that all matter exists in flux—eternally converging and dissolving—and that the human imperative is to live in harmony with the universe. In keeping with this aim he has never stayed with a particular style for very long, instead evolving as he responds to the changing influences in his life and environment over the years. This process is not always easy: as the artist has said, "Sometimes you have the feeling you're being pulled by a team of wild dogs."[2]

From the age of 16 Jensen had worked as a bridge builder, and by 20 he was a master carpenter. His knowledge of materials and comfort with craft aided his art-making practice. Not only did it inform his technique but some of his earliest paintings took their coiling imagery from spiral knots in the plywood he often used in construction.

The group of dark paintings that includes *Ashes* came into existence almost by accident. Jensen mixes his own oil paint, giving him an intimate familiarity with the properties of pigment.

When he ran out of a frequently used color, Egyptian Violet, he purchased Dioxin Violet instead. The pigment appeared to be the same deep purple, but once he mixed it with oil it turned black. Jensen was entranced and immediately began exploring this new dark palette, highlighting subtle gestures in jet black against a background of slate and eggplant. Though the act of purchasing a new pigment was the catalyst, the underlying impetus for *Ashes* doubtless reflected other events in his life: a few years earlier, in rapid succession, Jensen's home in New York City caught fire, destroying many of his wife's paintings and much of their property, and the city was the target of the 9/11 terrorist attack. We might infer that the eponymous title *Ashes* came from the injured world around him. The work took Jensen two years to complete. He has worked on some paintings as long as 16 years to get them just right. As he says, the painting itself tells him when it is finished.[3]

1 John Yau, "Drawing a New Line," *Art on Paper* (January 2004), 61.
2 John Yau, "Bill Jensen," *Bomb* 99 (Spring 2007), 26.
3 Chris Martin, "In Conversation: Bill Jensen with Chris Martin," *Brooklyn Rail* (February 2007), http://www.brooklynrail.org/2007/02/art/bill-jensen.

JUN KANEKO

(b. 1942, Nagoya, Japan)
Dango, 2005
Ceramic
25 x 18 x 11 in.

Untitled, 2006
Ceramic
26 x 16 x 9 in.

I want my sculptures to shake the air around them.
To stand just like they should be there in that space at that time.
The form and visual impact of these sculptures is most important to me.

Jun Kaneko has been credited with creating the largest freestanding ceramic objects in the world.[1] Though he also makes drawings, paintings, photographs, and installations, and has designed the sets and costumes for two operas (*Madame Butterfly* and *Fidelio*), clay is his primary medium. As a young boy growing up toward the end of World War II in Japan, his education was traditional, but his parents encouraged his aptitude for art. Kaneko had little interest in school and attended high school at night so that he could study under the painter Satoshi Ogawa during the day. After graduation, he painted full-time until he moved to Los Angeles in 1963. When he arrived in the United States, Kaneko spoke no English, and his initial linguistic and cultural isolation forced him to rely entirely on visual cues—an experience that heightened his senses and sharpened his perception of his environment. Arriving as a painter, the artist quickly fell in with the burgeoning scene of ceramic artists in Southern California, including the established master Peter Voulkos. Immediately seduced by the serious yet freewheeling style of these artists and the potential of clay as a medium, Kaneko applied himself to his new craft with dedication.

The artist's respect for clay and its inherent challenges led him to collaborate with the material rather than seek to control or dominate it. At any size, a ceramic object is potentially unstable during the firing process. As the kiln is heated and cools, the clay subtly expands and contracts, causing cracks. Over the years, Kaneko learned not only to accept that some works would break, but in some cases to intentionally induce breakage. This positive approach is characteristic of his art-making practice. While his level of skill and careful planning reduce the potential for mishaps, accidents inevitably occur,

forcing him to reconceive monumental works. The element of the unforeseen applies also to the color and glaze—in the kiln, a glaze that might appear gray while being worked can be fired to a brilliant blue, or a pale wash can turn a bright yellow. The artist cannot see how the finished work will appear while he is making it. Kaneko is intrigued rather than discouraged by the unique limitations and difficulties of scale, form, stability, and color inherent in ceramics. He has amusedly remarked that painting or drawing alone would be too "free" for him—he could be driven crazy by the multitude of possibilities.[2]

Kaneko's process-oriented method allows for long periods of thought; he spends as many weeks and months considering each sculpture as he spends executing it. This period of reflection prepares him for the many intuitive decisions he has to make while creating the object. He is deeply engaged with the Japanese Shinto concept of *ma*, which can be loosely translated as "the space between things"—for him, the relationship between an artwork and the space surrounding it.[3] The space surrounding Kaneko's work is benign; his curving forms are invariably pleasing, and their rhythmic and geometric designs draw the viewer's eye around and over the work in a compelling, almost trancelike, manner. It is a sign of his wit and kindly intent that the artist calls his vertical, oval, three-dimensional objects *dango*, a Japanese word that implies "rounded form," but literally means "dumpling."[4]

1 Maui Arts & Cultural Center, Kahului, Hawai'i, www.mauiarts.org, http://www.mauiarts.org/Newsroom/CrosscurrentsCatalog.pdf.
2 "Studio Visit with Jun Kaneko, Kamp Kippy," September 17, 2009, http://www.youtube.com/watch?v=meFCbeMgwo4&feature=related.
3 Susan Peterson, *Jun Kaneko* (London: Laurence King Publishing, 2001), 98.
4 Arthur C. Danto, foreword to Peterson, *Jun Kaneko*, 9.

38

ALEX KATZ

(b. 1927, New York, New York)
Tracy, 2008
Oil on board
12 x 15 3/4 in.

Alex Katz once described his artistic intention as "something hot, done in a cool way."[1] Over the artist's half-century career he has brought this paradoxical ambition to iconic portraits as well as landscape paintings and cutouts for stage sets.

The child of Russian immigrants, Katz grew up in Queens, where from an early age he had access to art in the form of the oil paintings that decorated his childhood home and the holdings of the many museums and galleries he visited in the greater New York area. Originally, he trained as a graphic designer, creating posters, book jackets, and magazine covers. His design work may either have reflected his own developing aesthetic or informed his method of seeing and thereby helped generate his signature style.

When Katz first began painting portraits seriously in the mid-1950s, abstract expressionism had a stranglehold on the New York art world. An ambitious and bold young artist, he wasted no time competing with the establishment and defiantly forged his own path with figurative representational work. In art school, where models often posed for only 20 minutes at a time, he acquired the ability to paint very quickly. This skill has served him well; for his current portraits, the model poses for a relatively brief hour and a half while he makes a study in oil on board. The next step is a charcoal drawing and the last a large-scale oil painting on linen. Even the largest of his works take no more than a day to complete. This rapid pace both reveals his technical ability and helps him achieve what he calls "reductive" painting. Reduction, for Katz, means capturing the essence of his subject, avoiding the distractions of stray details or out-of-place marks.[2]

Tracy is part of an unusual series from 2007–08 in which the artist reverses his erstwhile practice of facing the subject head-on. Every portrait in this series is a view from behind. Katz has spoken of having the sensation of painting "from the back of his head"[3]—indicating that for him the work comes from both a cerebral and physiological place. This oil on board study shows a looseness often absent from his large-scale works. His brush swirls and smudges around the figure, whose luminous, messy hair flies out of the dark background as if tousled by a light breeze. The artist has said that the use of "open brushwork"—in which edges blend and figures emerge almost organically from backgrounds—suggests the way certain human beings possess an energy that goes beyond themselves.[4]

1 David Cohen, "Gallery Going," *New York Sun*, October 9, 2003, http://www.artcritical.com/DavidCohen/SUN21.htm.
2 Robert Ayers, "Alex Katz," artinfo.com, January 18, 2006, http://www.artinfo.com/news/story/9528/alex-katz/.
3 Diana Tuite, *Alex Katz: Subject to Reversal* (Chicago: Richard Grey Gallery, 2008), unpag.
4 Smithsonian.com, "Behind the Canvas with Artist Alex Katz," video, 3:37, http://www.smithsonianmag.com/arts-culture/Cool-Katz.html?c=y&page=3#.

39

PER KIRKEBY

(b. 1938, Copenhagen, Denmark)
Untitled, 2007
Oil and tempera on canvas
45 1/4 x 37 1/2 in.

Per Kirkeby is a philosopher as well as a painter. He is also a sculptor, printmaker, draftsman, writer, historian, filmmaker, architect, poet, stage designer, and geologist. He earned a degree in geology from Copenhagen University, spending many months in the late 1950s and early '60s in Greenland sketching and studying rock formations. This early tutelage in the scientific method of careful observation has informed his art-making practice. Kirkeby believes that there is an inherent contradiction in the study of naturally occurring phenomena:[1] it is not possible to discern all of nature's processes at once; they evolve over time, and largely out of sight. He incorporates visual contradictions in his work, echoing this impossibility of perceptual truth.

Kirkeby is strongly moved by color, struggles with the dearth of primary colors in nature, and battles with the necessity of green, which he despises.[2] It could be said that color functions as form in his artwork.[3] His method is arduous; it often takes him many months to complete a single painting. Once the underlying structure of the composition has emerged, he disrupts the surface with graffiti-like marks and brushstrokes that add layers of complexity. The effect is a buildup of surface texture that resembles the geological sedimentation he spent his formative years studying so closely.

In *Untitled*, Kirkeby subverts the horizontal tradition of landscape painting not only by upending the canvas but also by making the strongest point in the composition a vertical stripe of bright yellow-orange light. This swath is echoed to a lesser degree in the violet and green streaks to either side of the center. The vertical impetus is intersected by strong curving horizontal marks in dark purple and black, forcing a dramatic interaction between the two. Effectively courting a challenging and ambiguous impression, he refutes a literal interpretation of either abstraction or representation. Kirkeby paints by intuition, seeking to capture the chaos and incoherence of reality. If his paintings can be interpreted as depictions of nature without the prism of logic, they can be seen as closer to the impenetrable truth of nature, with all that we have yet to understand. Instead of signing his paintings, he prints his name in capital letters on the back. Nature, he points out, has never signed anything.[4]

1 Thomas Elsen, *Per Kirkeby* (Cologne and New York: Michael Werner, 2003), unpag.
2 Siegfried Gohr, *Per Kirkeby: Journeys in Painting and Elsewhere* (Ostfildern, Germany: Hatje Cantz Verlag, 2008), 138.
3 Paul Levine, "Thinking with His Hands," *ARTnews* 96 (October 1997), 139.
4 Ibid., 140.

DAVID KORTY

(b. 1971, Los Angeles, California)
Study for Two Women Walking, 2007
Oil on linen
35 × 28 in.

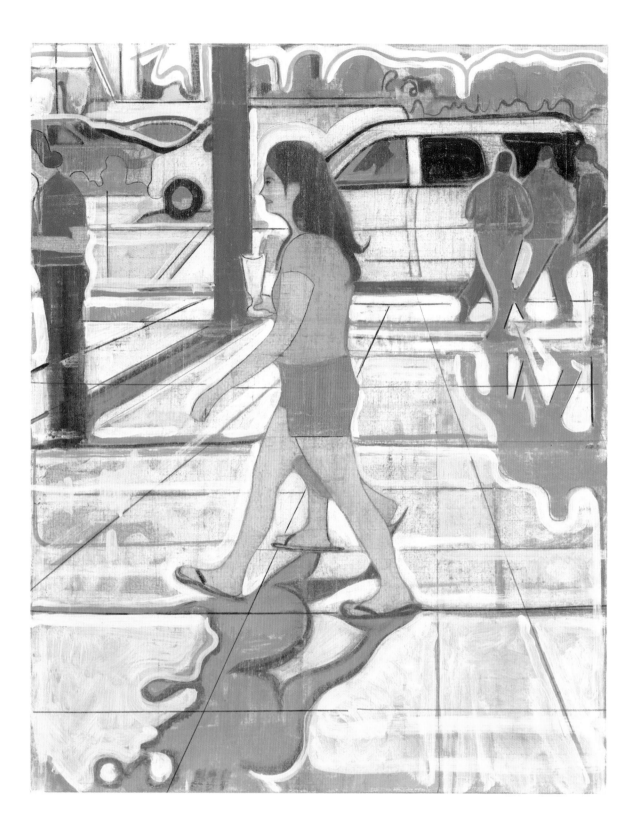

Painting for me is about looking and responding. Looking, in that I begin by observing the world around me, the city, the people, the cars, piles of trash. Taking photographs. I find fragments of these things that seem to ask to be made into paintings. It is a way for me to respond to the world around me. A way to connect the dots. Once I begin making a painting an entirely different set of variables arises. And once again I am looking and responding. And painting.

David Korty delights in the banalities of everyday life. His subjects have included parking lots, city streets, airport waiting areas, people bicycling through parks, and Disneyland. He celebrates commonplace areas populated with strangers by elevating them to almost archetypal forms—a Platonic ideal of passers-by on a city street or people reading on a bench. To prepare for his paintings, the artist walks the streets shooting slides. Back in the studio, he projects the images onto canvas and outlines them in graphite, turning the image into lines and shapes, taking considerable license with the source photograph. Finally, he applies layers of oil paint, which he tempers with layers of wax. While the paint is still wet, he blots it with newspaper or paper towels, giving the surfaces a subtle, grainy quality. Sometimes he uses a technique borrowed from printmaking, laying a sheet of newsprint over the entire wet surface of the painting, lifting it, and then reapplying it to the canvas, imprinting the painting with its own image. The flat, sketchy surface belies the dimensionality of the image, and our perception shifts from surface to depth and back again.

Study for Two Women Walking exemplifies Korty's dreamy style. As the title indicates, we see two women walk down a city sidewalk, one almost entirely concealed by the other. The sidewalk is rendered in traditional perspective, with lines receding toward the horizon, in this case the far side of the street. Blue shadows lyrically pool from the figures like puddles, reminiscent of the water in Paul Gauguin's *Day of the God (Mahana No Atua)* (1894). Though Korty's style is reminiscent of Gauguin, his palette and subject matter are more highly evocative of Georges-Pierre Seurat,[1] with whom he shares an idealistic pleasure in humanity and his own surroundings. With curvy lines, repeated shapes, and city grids he traces the connections between one person and another and the contextual relations of people with cars, streets, sidewalks, and buildings. Korty shows us the ordinary harmonies of daily life.

1 Julia Caniglia, "David Korty," *Artforum* 45 (December 2001), 118.

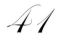

DANIEL LEFCOURT

(b. 1975, New York, New York)
Variable Value, 2004
Oil on linen
18 x 24 in.

It is a painting of a rock, about the size of one's head. Sitting there, black, obdurate, and opaque. Thick, monochrome paint. Shiny, but certainly not a gem or diamond. Its value is variable. It **is** a variable.

Daniel Lefcourt's work—video, sculpture, photography, and painting—lies somewhere between provocation and statement. In various exhibitions, works, and series, he has explored his interest in politics, hypocrisy, doublespeak, and the flow of information in the digital age.[1] In the exhibition *Put All Doubt to Rest*, in which the work *Variable Value* was first shown, he implicitly critiqued commodification while exploring meaning through the unlikely subject of rocks.[2]

At first glance, *Variable Value* appears to be an abstract black shape centered on a coarse burlap field. When seen from various viewpoints, however, the shape suddenly becomes three-dimensional. The angled brushstrokes reflect light at odd angles, throwing the ebony-colored form into glossy relief. This effect is magnified by the amusingly tiny grayish shadow underneath what we now realize is a solid, heavy rock. The pitifully inadequate shadow is an artful nod toward realism, making the stone seem almost cartoonishly monumental. Lefcourt's treatment gives the object oddly iconic status.

The artist's titles are often complex, at once explaining and complicating the work they describe.[3] The phrase "variable value" comments on the implications of elevating a mundane component of the natural world to the status of artistic subject. The question Lefcourt raises could be interpreted as a condemnation of the commodification of objects that takes place in the art world or, alternatively, as a sincere investigation into what constitutes genuine value. Anything that is for sale is worth whatever someone will pay for it. Issues of supply and demand affect perceived worth, and at a fundamental level value is always subjective. The widely coveted diamond is just another mineral and there are, in fact, a lot of them. A painting, however, is always one of a kind.

1 Katie Stone Sonnenborn, "Daniel Lefcourt: Taxter & Spengemann," *Frieze* 104 (January–February 2007), http://www.frieze.com/issue/review/daniel_lefcourt/.
2 Jerry Saltz, "Like a Rock," *Village Voice*, December 21, 2004–January 2, 2005.
3 Kelly Devine Thomas, "What's in a Name?," *ARTnews* 104 (November 2005), 172.

42

MCDERMOTT & McGOUGH

(David McDermott: b. 1952, Los Angeles,
California; Peter McGough: b. 1958,
Syracuse, New York)
My Happiness is Misery, 1966, 2008
Oil on linen
60 × 48 in.

Our photorealistic painting titled **My Happiness is Misery, 1966** depicts a Technicolor film still from **The Birds**, vertically positioned above a black-and-white still from **The Fountainhead**. The female protagonist in each frame emblematizes the film's emotional crisis, freezing the woman's identity and repositioning a trajectory of feminism within the context of 1950s and 1960s cinema.

David McDermott and Peter McGough are time travelers. They have been making art together for more than 30 years, and the way they have conducted their lives has been perhaps their most radical work. Rejecting most of the trappings, conveniences, and advances of modern times, they have existed as if in another century. At the beginning of their life together in the East Village of New York City in the 1980s, they chose the lifestyle of the Victorian era and dressed, ate, and behaved accordingly. Well known for their anachronistic existence, they wore hand-tailored suits and occupied a townhouse without TV, radio, electricity, or refrigeration. Their few concessions to progress included heat and a 1913 Model-T Ford for transportation. Since the '80s, they have chosen to embrace a wider range of eras: McGough currently lives as if in the early 1930s in New York, while McDermott remains in the late 19th century in Dublin. This adjustment of their self-imposed temporal constraints does not represent a slackening of their commitment to chronological alteration. It is simply the next step in their investigation of history as a lived reality. While their lifestyles could be viewed as Luddism, it would be more apt to understand them as an extreme form of nostalgia. McDermott once said, "I have seen into the future, and I'm not going."[1]

The artists have made photographs, paintings, and films, using whichever medium or technology was most appropriate to the era portrayed. This synthesis of medium and message is exemplified in every aspect of their existence. They backdate everything they create to the relevant time period. McGough relishes the confusion this practice would generate if their works were ever lost and then found, as he says, "after the bomb."[2] Although there would be clues in the works' themes—class, politics, money, sexual identity, or conspiracy theories—the medium and dated signature would thwart efforts to correctly locate them temporally.

My Happiness is Misery, 1966 is one of several works in a series that vertically pairs photorealistic images of scenes from two different films—one black-and-white, the other color. The scenes feature the reigning queens of cinema at the time, such as Lana Turner, Susan Hayward, or Claudia Cardinale. *The Birds* was made in 1963 and starred Tippi Hedren and *The Fountainhead* was filmed in 1949 with Patricia Neal. The title comes from the lyrics of the Jazz Age song "My Last Affair," written by Haven A. Johnson and popularized by Ella Fitzgerald and Billie Holiday. The artists have dated the work 1966, midway through a turbulent decade when the country was embroiled in war, and cultural, political, and social tensions ran high. McDermott & McGough celebrate the stylish presence these leading ladies offered at a time of national turmoil. In the movies, it is possible to cope with the most horrific tribulations without smudged makeup or mussed hair. Against the odds, the artists have demonstrated that it is even feasible to live as though in a different century. As McGough once said, "In art, there is no limitation."[3]

1 Glenn O'Brien, "Modern-Postism," *Artforum* 23 (October 1984), 63.
2 Peter McGough, interview in "Peter McGough: Artist," Revel in New York video, 16:00, December 8, 2009, http://www.revelinnewyork.com/videos/peter-mcgough.
3 Ibid.

MARILYN MINTER

(b. 1948, Shreveport, Louisiana)
Bloodshot, 2007
Enamel on metal
36 × 36 in.

This image happened after a very long day. I ended up shooting my makeup artist who had such extraordinary eyes. I just amplified, in the painting, what was already there.

Marilyn Minter's work can be dually perceived as a celebration and a send-up of commercial depictions of femininity, sexuality, pornography, advertising, and our entire gluttonous visual culture. She looks for the moment when something goes wrong—when her model begins to sweat under the lights, when her makeup runs, when her feet get dirty in very fancy shoes—and seizes that moment as her inspiration.[1] Her vision coalesces when cracks appear in the artifice of glamour and we catch a glimpse of the humanity beneath.

In *Bloodshot*, a beautiful blue-green eye is tired and red-veined, surrounded by clumps of overloaded mascara and shiny drops of perspiration that dot the surface of the upper and lower eyelids like gemstones. Minter is both a photographer and a painter, and her process reveals a symbiotic relationship between the two media. She begins by hanging all the images from a photo shoot on her studio wall and deciding which ones work as photographs and which as paintings. Once she makes this decision, she never revisits it. In the painting process, her next step is to scan the negatives and digitally manipulate them in Photoshop. Finally, she projects the prototypical image onto an aluminum surface and applies enamel paint to it with her fingers. The finished painting is made of layers and layers of enamel, and, if you look closely, you can see the artist's fingerprints all over the glossy surface. One of the intriguing paradoxes of Minter's deceptively complex work is that her jewel-like paintings are actually finger paintings.

Minter has been criticized for her subject matter—in the early '90s she notoriously created elegant paintings of pornographic subjects—and she counters by saying that she does not "cater to the patriarchy."[2] Her gaze is always sympathetic to the female; she celebrates women both as the gilded lilies of contemporary advertising and pop culture and as real human beings with tired eyes, runny makeup, perspiration, and dirty feet; somehow beautiful despite, or perhaps because of, their flaws.

1 Barry Schwabsky, "Beauty and Desecration," *Art in America* 95 (March 2007), 134.
2 Lisa Jaye Young, "Excess All Areas," *ArtReview* 66 (April 2005), 76.

KATY MORAN

(b. 1975, Manchester, England)
Graveyard Gazer, 2006
Acrylic on canvas
15 × 18 in.

Sensation is the word that resonates with me most. I think about marks, which to me seem either dead or alive. When paint is alive and has energy, it conveys through sensation. When paint behaves in an illustrational way, like a photograph or a graphic, it's understood intellectually, the brain registers a figurative image of something and then it moves on to the way the paint has been put on the canvas. Painting in terms of sensation means that the painting is felt first and then the brain slowly leaks back to the figurative image.[1]

The modest scale of Katy Moran's paintings—the largest are under two feet at their longest dimension—is overwhelmed by the energy of their gestural abstraction. Her working method is unusual in its degree of spontaneity. Due to a back problem, she paints with the small canvases on the floor of her studio,[2] turning them around and often creating most of the painting upside down relative to its eventual orientation on the wall. She begins to paint without any specific outcome in mind, starting with only a vague idea of an image culled from a book, a magazine, the Internet, or another artwork, from which she almost immediately departs. Working on up to three or four canvases at a time, she also refers to her other paintings hanging on the walls of the studio. She has compared this relational method to coordinating an outfit of clothing;[3] some things go together, others don't. She works the surfaces of her canvases until she sees the barest hint of a figurative element emerge, at which point she knows the painting is complete.

Graveyard Gazer demonstrates Moran's technical ability and emphasis on form over literal content. With its evocative smears and brushstrokes, the painting is an elegant interplay between perceptual depth and flatness. The lushly applied, gestural layering would be almost sensuous if the palette weren't confined to sooty shades of gray and silver, deepening to black smudges at the corners. The focal point of the canvas is a pair of bright white daubs—still forms surrounded by agitated motion. As with all of Moran's work, her mark making defies codification—generating its impact solely through energy and movement. She likes the painting process to be

visible to the viewer, not because of any philosophical conceit or intended reading, but rather because of an aesthetic concern with spontaneity. What might have occurred as an accident —a drip or flaw—can become the element that brings the entire composition into harmony.[4]

Moran's focus on process and the natural evolution of an image, rather than any attempt to specify or dictate content, extends to her titles as well. They are culled from newspaper fragments, half-remembered conversations, and passing moments that catch her fancy. *Graveyard Gazer* could have started as having something to do with a cemetery—the ashy colors are reminiscent of tombstones—or it could just as easily have arisen from a personal experience, a joke she overheard, or a news story. Rather than capturing a single moment in time, Moran offers us a poetic mélange of visual and verbal references for our own interpretation.

1 Katy Moran, artist statement in *Katy Moran* (St. Ives, Cornwall, England: Tate St. Ives, 2009), unpag.
2 Melissa Gronlund, *Katy Moran: Paintings* (Middlesbrough, England: mima [Middlesbrough Institute of Modern Art], 2008), 70.
3 "Interview with Sarah Hughes," *Katy Moran*, n.p.
4 Ibid.

MUNTEAN/ROSENBLUM

(Markus Muntean: b. 1962, Graz, Austria;
Adi Rosenblum: b. 1962, Haifa, Israel)
Untitled, 2001
Acrylic on canvas
76 3/4 x 35 1/2 in.

IT IS NOT OUR FEAR OF DOING WRONG THAT PARALYZES US, BUT OUR FEAR
THAT IN DOING WRONG WE MIGHT NOT SUCCEED.

This painting belongs to a body of work developed between 1998 and 2003. The painting is characterized by references to the way we perceive things today, which is influenced by the media, advertising, film, and popular culture. The picture reflects TV frames as much as it refers to comic strips or "the art director's gaze." Muntean/Rosenblum consider their art to engage with themes from the history of painting and art.

The figurations are modeled after lifestyle magazines such as **ID**, **Face**, **Vogue**, etc., which provide the stock of compositional elements and figures. These belong to a lifestyle-oriented society where youth is a marketable commodity and "being young" has become an instrument of permanent self-control. The magazines cooperate with specialists in affective image production, appropriating forms that used to stand for protest, utopia, and delimitation, as well as allegorical themes and subjects from art history. The subjects are brought together with strange lines of text or statements reflecting seemingly individual or societal issues while at the same time creating some sort of surreal or banal disconnectedness.

The contemporary bricolage of the team of Markus Muntean and Adi Rosenblum raises issues of substance and idealism within the framework of popular culture and consumer society. Muntean/Rosenblum, as the collective is known, has been making art since 1992. Its members, Austrian-born Muntean and Israeli-born Rosenblum, collaborate so seamlessly that they are able to function as a single artist, with no distinction in authorship or style. Although they create films, sculpture, and installations, they are best known for enigmatic paintings of seemingly disaffected young people. Illustrative images of young men and women posed in forests, vacant lots, interiors, or on railway tracks, are presented with rounded corners against white backgrounds—an overt reference to TV screens or comic books. Each of these figures is assembled like Frankenstein's monster, sampled from images found in advertisements and articles in teen and lifestyle magazines. An arm might come from one source, a leg from another, and a head from somewhere else. This constructed identity contributes to the overall impression of ennui emanating from the listless figures. Their gaze is expressionless, their postures artificial and awkward. Whether alone or in a group, they project a sense of overarching loneliness and isolation. The backgrounds are suffused with emptiness—neutral to the point of banality. Each painting contains a neatly hand-lettered caption unrelated to the figures depicted. The text is also appropriated, from classic or popular literature, and may take the form of an aphorism, a narrative, or a question.

Muntean/Rosenblum's work can be seen in a number of ways: as classical mannerist painting, as social critique decrying the materialism of youth-obsessed culture, as voyeurism, as nostalgia, or as ironic and detached appropriationism. No single interpretation explains it all, as befits work characterized by what the artists call "precise ambiguity."[1]

1 Leah Turner, "Heaven Knows I'm Miserable Now," *Color Magazine* 7 (Autumn 2009), 85.

TAKASHI MURAKAMI

(b. 1962, Tokyo, Japan)
Jellyfish Eyes Nega, 2001
Acrylic on canvas
15 3/4 x 15 3/4 in.

Takashi Murakami is often referred to as "the Japanese Andy Warhol."[1] He frequently cites the pop master as an influence,[2] and extends Warhol's groundbreaking blurring of the lines between commerce and art, lowbrow and highbrow, mass production and artistic craft, effectively erasing these boundaries. Murakami grew up studying Western art, though he received a Ph.D. degree in Nihonga—a Japanese painting tradition calling for natural pigments and the adherence to rigid constraints in style and themes—and initially pursued a career in animation. Today drawing his inspiration mostly from *anime* (Japanese animation) and *manga* (comics), Murakami makes everything from sculpture, painting, film, and digital animation to T-shirts, keychains, mousepads, toys, Monopoly games, and handbags for Louis Vuitton.

Murakami is president of the corporation Kaikai Kiki (named after his "spiritual guardian" *manga* characters), which creates and promotes artwork, artists, merchandise, and animation. The corporation is housed in a series of buildings outside Tokyo called the Hiropon Factory after the Japanese street name for crystal meth and Warhol's famous Factory. In order to make art quickly and efficiently, Murakami and his team of assistants pull digital images from his electronic archive of standard motifs (eyeballs, flowers, mushrooms) and characters (Mr. DOB—the artist's alter ego—Kaikai Kiki, Mr. Pointy, and many others). Murakami manipulates the motifs, characters, and assorted backgrounds in Adobe Illustrator until he has found an image he is happy with, which he then prints out and gives to his assistants. The team silkscreens the image onto canvas and begins to paint.

Jellyfish Eyes Nega depicts the multiple eyes with "cute" lashes that the artist frequently adds to his characters and surfaces, perhaps suggesting that everything sees and is being seen simultaneously. The word *nega* refers to a photographic negative, evoked by the reversal of color in the stylized eyes: the lashes are white, the irises black and red, and the pupils with their light-spots are pink. The title also refers to the literary source for this image: "Jellyfish Eyes" is an old *manga* story. Its main point is that the jellyfish have no eyes, making the tale, in Murakami's words, a "nonsense story."[3]

Though the bright colors and relentless cuteness of almost everything the artist and his company produce may be delightful, the work has a hidden edge. There are many smiles on flower-faces, Murakami says, because sometimes it is hard to smile. His host of comic spirit-guardians fail him occasionally, and Mr. DOB appears on the canvas bloated and vomiting. The recurring theme of mushrooms is often assumed to refer to psychedelia—"magic mushrooms"—but the artist explains that they are a reference to the atomic bombs the United States dropped on Japan during World War II. Murakami's mother impressed on him as a child that he owed his life to the cloudy weather on August 9, 1945, that diverted a B-29 from Kokura (where she lived) to its secondary target of Nagasaki.[4]

Murakami subtly dares us to look beneath the cute, beneath mass production, marketing, commerce, and fashion to discover something real and true about world history and the human condition.

1 Madeleine Brand, "Takashi Murakami, Japan's Andy Warhol," NPR broadcast, 4:24, September 15, 2003, http://www.npr.org/templates/story/story.php?storyId=1431797.
2 Jim Frederick, "Move Over, Andy Warhol," *Time Magazine*, May 19, 2003, http://www.time.com/time/magazine/article/0,9171,452870,00.html.
3 Museum of Contemporary Art, Los Angeles, "An Exhibition Tour With Takashi Murakami," video, 6:12, 2007, http://www.moca.org/murakami/index.php?video=11.
4 R. C. Baker, "Takashi Murakami's Smog of Luxury," *Village Voice*, April 15, 2008, http://www.villagevoice.com/2008-04-15/art/mr-jellyfish-eyes/1.

YOSHITOMO NARA

(b. 1959, Hirosaki, Japan)
Pup King, 2000
Acrylic on canvas
49 × 59 in.

It's been a long time since I rented and worked inside the storage-like studio space in Venice Beach with no windows, as if to avoid the strong California sun. Not knowing whether it was day or night, I would just simply paint with music flowing from the radio as my companion. Is he drifting afloat in the darkness, or sprawling out . . . a tired-looking pup king with no attendant. We were together in the same space, listening to the same music. Although this painting is no longer in my hands, he lingers inside my heart even now.

Yoshitomo Nara has said that most of his paintings are self-portraits.[1] This is not necessarily obvious, given that his subject matter consists almost exclusively of children (particularly little girls) and dogs. Children and dogs have something in common, however; they are smarter than adults often perceive, yet they live in a state of dependence, subservience, and vulnerability. The artist identifies with the archetype of the alienated outsider.

Nara's childhood was lonely. He grew up in the countryside of northern Japan as a self-described "latch-key kid" whose parents both worked.[2] He has vivid memories of long hours spent playing with his pets—cats and dogs—as well as the family's sheep and cows. He would watch cartoons on TV and draw to while away the hours. As an adult, he moved to Germany to attend the Kunstakademie Düsseldorf. He spoke very little German and was thrilled when anyone conversed with him; the isolation he experienced was much more significant for him than any of his classes. Solitude brought his childhood to the forefront of his consciousness and he began integrating his memories into his art. Although his work is often associated with *manga*,[3] Takashi Murakami's "Superflat" movement,[4] and the style known as *kawaii*[5] (in Japanese, "cute"), Nara explains that he does not seek to affiliate with any of these idioms, but rather is simply aiming to recapture his boyhood.[6]

Nara works alone in his studio, without assistants, often late into the night. He plays punk rock loudly to create an environment of chaos to which he responds with a process

he compares to a guitar "jam"[7]—he knows what he's doing but he doesn't think about it or what he is going to do next.

In *Pup King*, Nara has elevated the underdog to a monarch, a token upgrade for the disenfranchised everywhere. The lonely "pup" lies flat on a washy background, his eyelids drooping from world-weariness. The colors seem slightly faded, as if nostalgic for an earlier time. As surrogates for the artist, his children and dogs possess a quality of defiance, whatever their circumstances. The children smoke cigarettes, start small fires, and are occasionally armed with child-sized knives. As in *Pup King*, his dogs' tails are always wagging, an open-armed invitation to empathy, compassion, and love. Even though dogs' existence is determined by others—"Sit!" "Stay!"—they remain man's best friend. Therein lies the hope in Nara's work. Wrongs have been committed, anarchy may be afoot, but there is always a chance for redemption.

1 Kimberly Chun, "Killer Cute," *San Francisco Bay Guardian*, September 15–21, 2004.
2 Eric Nakamura, "Punk Art," *Giant Robot* 20 (Spring 2001), 24.
3 Andrew Fenwick, "Manga Inspired Designers: Yoshitomo Nara + Graf," *Metro UK* (London), June 23, 2008.
4 "Superflat Art: Yoshitomo Nara," http://www.superflatart.info/yoshitomo_nara/.
5 Peter Chapman, "Pick of the Week: Yoshitomo Nara + Graf," *Independent* (London), July 12–18, 2008, 13.
6 Keiko Ohnuma, "Beyond Cute," *Honolulu Star Bulletin*, April 10, 2005.
7 Christopher Collett, "Young art runs free," *Metro UK* (London), June 13, 2008, 33.

48

TODD NORSTEN

(b. 1967, Sunburg, Minnesota)
Repent or Perish, 2006
Oil on canvas
60 × 48 in.

Repent or Perish is from a photo I took at a county fair. When I saw the person wearing the shirt, it made me think of the practice of painting. The statement "Repent or perish" has been used long and hard, so much so that the original idea is lost or has become a cliché. The person who made the shirt must have connected with the original idea of repenting and perishing. The experience of seeing something that looks simple or even stupid but its being complex are qualities I appreciate.

Todd Norsten notices the extraordinary in the ordinary and brings it out in his work. Central to his art making is his practice of keeping a visual diary;[1] he photographs whatever catches his eye, whether positive or negative, amusing or frightening, or both. His subject matter has included commercial signs, graffiti, stills from television and movies, found objects, dolls, and melting ice. These disparate things are tied together by their seeming banality. Mundane, apparently insignificant, they are occasionally upsetting or absurd. Norsten elaborates his perceptions on paper or canvas, recording not the precise image of his photograph but his reaction to it. This process mediates his initial observation, constructing it as something permanent and public.

Often these uneasy explorations involve radical or reactionary slogans, as Norsten finds them in the quotidian vernacular. "Repent or perish," a glib paraphrasing of Luke 13.3 from the New Testament, has evolved into a threatening slogan meaning, essentially, "Join us or die." Yet it is readily available for purchase on coffee mugs, baseball caps, bumper stickers, and T-shirts. T-shirts are as American as blue jeans, the flag, and apple pie (which Norsten also depicts). Wearing a T-shirt that boldly proclaims a controversial idea is a particularly American freedom.

Norsten explores these conceptual preoccupations in a deceptively simple manner—we quickly grasp the icon of the blue T-shirt with black lettering—but his painterly touches are everywhere. He often makes his backgrounds white, carefully filling them in with faintly visible brushstrokes so that no two are ever the same. The blue of the T-shirt is not constant either, but washy and in some places smudged. The lettering of the slogan is deliberately a little unsteady, its dark black leaking into the white outline and through to the blue of the shirt. The initial impression of artlessness is belied by the evident workmanship. A peril inherent in freedom of speech is speech itself—people throwing around words carelessly, as if they didn't mean anything, saying thoughtless or dangerous things. *Repent or Perish* reminds us, gently but firmly, that words are important.

1 Todd Norsten, *The Masterworks* (New York: Cohen and Leslie, 2008), unpag.

49

THOMAS NOZKOWSKI

(b. 1944, Teaneck, New Jersey)
Untitled (8-61), 2005
Oil on linen on panel
16 × 20 in.

Untitled (8-61) is one of the very last paintings I made in a 16-x-20-inch format. It is part of a group of paintings—extending through my entire career and continuing today—that struggles to find the most reduced way of depicting a complex visual idea, the least way to mean something very specific. The subjects of this group of paintings change from panel to panel, the desire to find the heart of an image remains the same.

For Thomas Nozkowski, painting represents the near-perfect union of seeing, feeling, and experience, and as such is both universal and unique. Though he never reveals the specific subjects of his abstract paintings, he explains that his work arises from daily life. He transmutes his experiences into something else entirely and the finished painting carries all the meaning he hopes to convey.[1]

Nozkowski's work is comparatively small. For 15 years he worked in the 16-x-20-inch format of Untitled (8-61), only recently expanding to a moderately larger 22-x-28-inch size. One reason for the modest format is expedience—if he realizes halfway into a painting that the background is the wrong color, he can start over without losing days of work. The preference also has an ideological basis; he studied abstract expressionism at Cooper Union in the 1960s and reacted to its customary dramatic scale by creating art that might comfortably hang on his friends' walls rather than those of corporate lobbies or other impersonal public spaces.[2]

Nozkowski's scale limitation makes his use of form and color pack an even bigger punch. He sets further restrictions upon himself, such as using only one paintbrush from beginning to end in a painting or using a large brush to fill in small areas and a small brush to fill in larger ones. These strict and challenging rules are counteracted by his mental practice of free-associating while sitting at his easel. Within the artist's self-imposed structure, his imagination runs free.

It has been said that a solo show of Nozkowski's work could be mistaken for a group exhibition, so different are his small horizontal canvases from one another.[3] However, if one views his oeuvre in its entirety, certain formal concerns and color choices define a distinctive vision. In Untitled (8-61), for example, quirky geometric forms exist in harmonious interplay against a deep field of flat color. These shapes seem to shift, almost imperceptibly yet dynamically, within the picture plane. Another recurrent technique is the use of a monochromatic red undercoat beneath the intentionally imperfect shapes. Instead of descriptive titles, Nozkowski uses a series number followed by a painting number—this is the 61st work in series 8. A simple way to describe a work of intriguing complexity.

1 Julie Belcove, "Major Tom," W (January 2008), http://www.wmagazine.com/artdesign/2008/01/thomas_nozkowski.
2 Sarah Milroy, "Do you see what I see? No? Good," Globe and Mail (Toronto), August 22, 2009, R1.
3 David Pagel, "Invited into the Abstract," Los Angeles Times, May 13, 2005.

50

RICHARD PATTERSON

(b. 1963, Leatherhead, England)
A Small Lot of Love, 2008
Oil on canvas
36 1/4 × 32 in.

Jaguar's new design direction represents the interface of art and design as antithesis to the mundane pseudo-pragmatism of contemporary auto manufacturing. This is more than just an issue of appropriate business models or survival in the marketplace, but a deeper philosophical issue about how we accommodate the notion of sensuality, beauty, and pleasure in an increasingly bereft and valueless culture that is fixated on the decadent mix of entitlement and puritanism that ultimately places us in a second dark age.

Jaguar runs contrary to this backward cultural tailspin of pointless, clamoring gimmickry over vision by offering carefully and passionately thought-through cars that embrace modernity, technology, and unadulterated sensuality as expressed through design. At that point where design reaches a total clarity and singularity of purpose, design approaches, and may even eclipse art. My paintings tacitly acknowledge and relate to all of these issues.

It is impossible to separate the individual meaning of one of my paintings from all the others that I have made.

Richard Patterson is an idiosyncratic perfectionist. He combines found objects and images with an invented personal mythology and technical virtuosity. His topics have included celebrities (the Spice Girls, Raquel Welch, Dustin Hoffman, Jon Voight), cultural icons (the Dallas Cowboys Cheerleaders, the U.K.'s Thomson phone book), as well as mundane objects such as a wooden box, children's plastic toys, and his favorite hat. A recurring theme is cars or motorcycles, especially surrounded by bikini models culled from 1960s advertisements. Patterson gives all his subjects equal weight, though often almost entirely obscuring them with swirls of oil paint. He has cited as influences Barnett Newman's "zips," paintings by Jasper Johns that incorporate objects, and Picasso's images of the lonely Minotaur,[1] but his work is perhaps most reminiscent of James Rosenquist's sprawling pop murals of readymade glamour.

Patterson begins by spreading a sheet of acetate over a found image and gobbing paint onto it with visceral abandon. He then photocopies the result, enlarges it, and painstakingly copies it in oil on canvas. In A Small Lot of Love, a blurry found image of a bikini pinup is bifurcated by what looks like shelves covered with soft-serve ice cream or whipped cream. The peroxide blonde fades into the background while the delectable swirls of white

paint (or snow or icing) loom large in the foreground. While the main compositional elements are not fundamentally at odds (many would enjoy ice cream or snowy mountain peaks with a comely babe), the viewer is thwarted by the forcible reversal of foreground and background. The shelves act as visual barriers, frustrating the viewer who can never fully see the bathing beauty trapped behind them. Patterson makes a mockery of conditioned desire.

Most of Patterson's work evokes a similar kind of visual discomfort, and we are left with many questions but few answers. The artist himself is playfully disingenuous when interviewed: Is he serious? Yes and no. Does he take art history seriously? No and yes. Will he ever explain a particular painting's content? Probably not. One final question can certainly be answered, however: Has he invented a new kind of conceptual photo-realism? Most definitely.

1 Stuart Morgan, Paintings by Richard Patterson (London: Anthony d'Offay Gallery, 1997), 22, 30, 42.

51

PHILIP PEARLSTEIN

(b. 1924, Pittsburgh, Pennsylvania)
Portrait of Jim Dicke II, 2006
Oil on canvas
48 × 36 in.

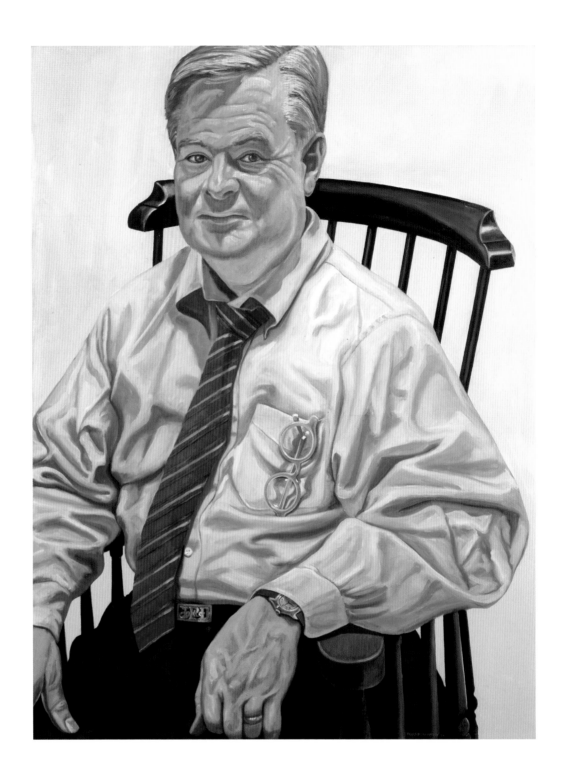

Painting the portrait of Jim Dicke was a pleasure for me. As I paint only from direct observation of my subject, we first determined how Jim would be dressed: informally in his blue shirt with a necktie, but without his suit jacket, and with his eyeglasses lodged in his shirt pocket. Then I made sure that his pose was comfortable and one that he could resume over an extended series of sessions. While I painted him we entertained each other with stories of past experiences. Jim was especially interested in hearing about my studies in art history: the research that went into my Master's thesis on the Dada artist Francis Picabia and his associate Marcel Duchamp, and my interpretations of the iconography in their works from the years 1910 to 1922. He even borrowed my only copy of the typewritten manuscript to read and a couple of sessions later presented me with several facsimile copies of the thesis that someone on his staff had made, even finding the archaic spring-back binders that held the hundred and seventy pages together. I was very touched by the extraordinary generosity of that gesture. It is one of the few portraits I have done in which my subject looks pleased.

Philip Pearlstein developed an inimitable brand of realistic portraiture in the 1950s, when abstract expressionism was at its height, and his independence has been vindicated by six decades of success and critical relevance. His approach grew out of his experiences as a young man during and following World War II. Drafted in the early 1940s, his service included making lithographs and silkscreen prints of infantry training charts and weapons such as rifles and machine guns. After the war, he was stationed in occupied Italy, and while painting road signs for the Army was able to study the great Renaissance masters in Rome, Florence, Venice, and Milan. After graduating from the Carnegie Institute of Technology in Pittsburgh on the GI Bill, he moved to New York, where he roomed for a while with his college classmate Andy Warhol. While in Pittsburgh he had made brochures of architectural products for an aluminum company, and in New York he worked for a graphic designer, illustrating catalogues for companies like plumbing supply manufacturer American Standard. This early training in detailed mechanical illustration may have informed his later artistic working method.

Pearlstein is known for painting both nude models and clothed portraits of friends or art-world luminaries. The critical difference between these two subjects is that with the nudes the human body functions as a formal element in the composition rather than as a person. Pearlstein's compositions are daring: he typically crops his images in unusual ways that carve up the figure. Occasionally a subject's head is cut off entirely, or only the legs are visible. Pearlstein paints exclusively from life, and his paintings evolve over weeks or months, depending on the sitter's availability. This method precludes the use of natural light, as its strength and direction changes by the season, the hour, and the minute. The artist works instead with artificial light, which can be controlled and positioned in the same spot for repeated sessions. After posing his subject, Pearlstein outlines the composition on canvas with charcoal. This enables him to see the portrait as an array of shapes and forms that fit together like a jigsaw puzzle.[1] He then paints exactly what he sees, whatever the discrepancies and tricks of perception.

PHILIP PEARLSTEIN

Despite Pearlstein's deliberate method he conjures a sense of urgency—trying to capture a fleeting moment before it irrevocably changes.[2] He finds painting people particularly exciting, for no matter how determined they are to keep still, they are constantly thinking, responding, and evolving. The portrait of Jim Dicke II shows many of Pearlstein's signature touches. The subject's right arm is cropped by the canvas edge, as is the top of his head. The artist does not see this as "cropping" a hypothetical larger scene, but as the result of his practice of beginning a painting at its most challenging point and letting it grow outward.[3]

Pearlstein once wryly commented that shirts and ties were often much more difficult and time-consuming to paint than a face. This could certainly be the case with the elaborately wrinkled shirt here, each fold a three-dimensional symphony of luminous blues. The portrait is foreshortened, a trick of perspective that is one of the artist's favorite formal devices. He has said, "Optical truth reveals the lie of conventional schoolbook perspective. Cézanne was right."[4] This composition lies just at the edge of awkwardness, yet adeptly captures humor, personality, and a real connection between artist and subject.

1 Michael Kimmelman, "Real Flesh, Not Perfect or Prurient," New York Times, May 24, 2002, E41.
2 Ibid.
3 Phong Bui, "Philip Pearlstein in Conversation with Phong Bui," Brooklyn Rail, no. 40 (September 2005), 13.
4 Michael Kimmelman, "Art in Review: Philip Pearlstein," New York Times, April 13, 2007, E34.

52

RICHARD PRINCE

(b. 1949, Panama Canal Zone)
In Morning, 2002
Acrylic on canvas
89 × 75 in.

Richard Prince's deadpan aesthetic reveals wit and perspicacity as well as technical mastery. He was born in what is now Panama to parents who worked as intelligence agents for the U.S. government. When he was six, the family moved to a suburb of Boston that the artist recalls as reflecting a kind of generic American 1950s affluence—identical houses, new cars, TVs, and wall-to-wall carpeting. His developing awareness of his own cultural transplantation may have paved the way for his later exploration of authorship, individuality, and appropriation.

Prince moved to New York City in 1977 and found employment in the tear-sheets department at Time-Life, ripping up magazines like *People*, *Sports Illustrated*, *Fortune*, and *Time* and delivering the editorial pages to the relevant departments. He was left with the advertising pages, which proved to be a rich source of inspiration. As he examined the ads, their subject matter seemed both ambiguous and universal and he began to photograph them, often zeroing in on figures or details. These first experiments became his now-famous *Cowboy* series, with images appropriated from Marlboro cigarette advertisements. The cowboys depicted wear traditional western attire, complete with 10-gallon hats, and ride horses across deserts. These quintessentially American tableaux stirred a wave of controversy as Prince skirted copyright infringement to explore our national identity. The artist steadfastly argues that his images are his own, as they are distorted and fragmented departures from the original.[1]

In addition to cowboys, Prince's subjects have included bikers' girlfriends, muscle cars, pulp fiction, nurses, and celebrities. *In Morning* belongs to the *Jokes* series, which marked an important turning point in his oeuvre. For the first time he turned to painting, because he wanted to present radical subject matter—the "low" art form of common one-liners—in a very traditional way. The early *Joke* paintings were comparatively simple. Prince began by copying cartoons with captions, but soon dropped the image and presented the text alone on a monochromatic background. Wanting to interact with the

words in a more tactile fashion, he hand-lettered the text and made the backgrounds increasingly painterly. With *In Morning*, he explored washes and drips of the full range of the color gray, from black to white. The jokes themselves are culled from books, magazines, and newspapers. Prince only uses jokes that he finds amusing or, occasionally, that he claims not to understand.[2] He describes this series with characteristically dry humor: "The *Joke* paintings are abstract. Especially in Europe, if you can't speak English."[3]

The artist's working method is determinedly solitary. At his farm in the Catskills, he often spends the better part of a week working alone in his studio. He sketches on pictures of de Kooning drawings as readily as he deconstructs the GT cars that he loves, casting their hoods as sculpture or replacing their engines with cement blocks. The only discernible theme is a particularly American kind of democratic and catholic diversity of interest. Everything is accessible, and equally engaging. Though his skill and individuality are abundantly evident in his creations, all his working methods devalue the concepts of authorship and identity: the jokes are so old, or so common, that no one remembers who told them first; the cars are mass-produced; the images are from magazines; the de Koonings are reproductions. Prince signs publicity photos of celebrities himself, often deliberately misspelling their names or misidentifying them. Nothing is sacred, but in a strange way everything is very important, and the artist takes things very seriously, most of all his *Jokes*.

1 Andrew Goldstein, "Richard Prince and Gagosian fight back over copyright," *Art Newspaper* 201 (April 2009), http://www.theartnewspaper.com/articles/Richard-Prince-and-Gagosian-fight-back-over-copyright/17147.
2 Marvin Heiferman, "Richard Prince," *Bomb* 24 (Summer 1988), http://bombsite.com/issues/24/articles/1090.
3 Steve Lafreniere, "Richard Prince talks to Steve Lafreniere—'80s Then—Interview," *Artforum* 41 (March 2003), http://findarticles.com/p/articles/mi_m0268/is_7_41/ai_98918646/pg_2/?tag=content;col1.

53

DAVID RATCLIFF

(b. 1970, Los Angeles, California)
Forest with Frosting, 2007
Acrylic on canvas
84 × 72 in.

The **Forest with Frosting** painting is perhaps the most literal of a group of works where I had used images of nature as stand-ins for painterly expression. Every painting of mine starts out as a photo-collage, but beginning with the group of which **Forest with Frosting** is a part, the collage process began to employ more "jump cuts"—illogical breaks, visible slices—as well as layered images, without necessary concern for what might be obfuscated in the process. I'd been thinking about Kiefer's works from the '80s, and in a very different way about Schnabel, whose paintings always look to me like "movie paintings," works from the studio of some fictional artist-character.

David Ratcliff has been compared to Andy Warhol,[1] in terms of both aesthetics and ideology. Like Warhol, Ratcliff makes work that is fundamentally inscrutable—it is simultaneously full and empty, positive and negative, a spoof and a celebration. His method is a mixture of high- and low-tech processes. Trolling the Internet for inspiration and photographic source material, he amasses volumes of found imagery that he digitally slices up and composes into a collage. Once he has created an image using a graphic program, he prints a template on standard-grade office paper. After cutting up the sheets of paper with an X-Acto knife to make a large stencil, he tapes it onto canvas. The background is always either black or white. After choosing a color (blue, red, yellow, pink), Ratcliff spray-paints the image onto the canvas through the stencil. The process destroys the template and allows for considerable "bleeding." While creating and stenciling the image and then attaching it to the canvas can take up to two weeks, the spray-painting takes only about 20 minutes.

During the paint application stage, two important aspects of Ratcliff's approach—chance and accident—present themselves. The artist deliberately creates the stencil out of fragile paper instead of a more durable medium. The destruction of the template not only guarantees that each work is unique (even if the mangled stencil is reused, the pattern is permanently altered) but also that the artist's plan takes the artwork only so far—the rest is up to the materials. The stencils represent partially abstracted images, created incrementally as the artist collages together found photographic

imagery. He takes abstraction a step further with his idiosyncratic painting process. Ratcliff has spoken about his desire to remove evidence of his own hand in the making of the work of art. In his view, the only evidence of authorship in the finished product should be the trace marks made by the tape holding the stencil to the canvas.[2]

The artist's ambivalence about his role as creator may arise from his complex relationship to his subject matter. In *Forest with Frosting*, the subject is a pleasant woodland scene, yet it is upended and obfuscated with calligraphic marks and designs. Nature is simultaneously represented and abstracted. Often Ratcliff's work includes imagery he actively dislikes—chosen to signify his dissatisfaction with the violence, materialism, and consumerism that he believes to be ubiquitous in American culture. By using pictures that he deplores, Ratcliff distances himself from his topics. He worries that this might be seen as an abnegation of responsibility,[3] though it could also be construed as even-handed objectivity. Though the artist has likes and dislikes, and something like an agenda, he does not force his views on anyone. A recent series evokes Rorschach tests, an invitation to the viewer to fill in the blanks in his negative space.

1 Michael Amy, "David Ratcliff at Team," Art in America 94 (January 2006), 123.
2 Bob Nickas, "Interview with David Ratcliff," defect's mirror (New York: Team Gallery, 2008), 56–57.
3 Ibid., 61–63.

54

PETER ROSTOVSKY

(b. 1970, St. Petersburg, Russia)
Swimmer with Goggles, 2004
Oil on linen
38 × 56 in.

Swimmer with Goggles is part of the **Swimmers** series that occupied me from 2004 to 2006. This body of work marks my return to a more humanistic and painterly approach in my practice. Derived from photographs of swimmers taken in Nice and at local New York beaches, each painting simultaneously serves as a study of local light and color as well as an individual portrait of the swimmer. Here each person is caught in a moment of isolation, meditative repose, or concentrated effort. Each is adrift, the endless expanse of water acting as much as a metaphor for life as it is for the medium of paint itself.

Peter Rostovsky's talent for realism has presented itself in a number of subversively surreal ways. He has made quirky and complex installations involving painting, sculpture, and film. Some of his best-known series are *Utopian Portraits*, *Epiphany Models*, and *Swimmers*. In the *Utopian Portraits* he paints the models from behind, as though we were looking over their shoulders as they stare up into the middle distance. Across from the portraits he positions the objects of their gaze— small paintings of sunsets or the sun breaking through on a cloudy day. We can walk through the subjects' line of vision, but we cannot see their faces or eyes. The *Epiphany Models* are mixed media installations in which six-inch-high sculptural figures of hikers are positioned on pedestals from which they photograph full-scale paintings that echo the sublime landscapes of the Hudson River School. Rostovsky uses his facility with paint to ask questions about reality and perception and to nudge the viewer out of the comfort zone of easily categorized media.

With the series *Swimmers*, the artist shifted from depicting people observing nature (seeing, hiking, photographing) to showing people experiencing nature. The images record an actual reality for the first time. During a residency in Giverny, Rostovsky traveled through France and photographed swimmers in the Mediterranean resort of Nice,[1] and continued once he returned to New York. Transformed into oil, the ripples and waves—occasionally breaking—vary in color from gray to blue and green. While the subject of water

may recall Vija Celmins's[2] painstakingly realistic drawings and prints or Roni Horn's darkly forbidding lithographs of the Thames, Rostovsky's *Swimmers* is a jump ahead in evolution— there are people. They swim determinedly or float, alone or in groups, borne along as if held in utero by the ocean. The surface of *Swimmer with Goggles* shimmers between depth and flatness, mirroring the optically impenetrable sea. Here there is nothing of the irony or humor of the artist's previous work; this time he depicts real life, inviting us in to share a moment of contemplation with his swimming subjects.

1 Max Henry, "Peter Rostovsky," *Time Out New York*, no. 439, February 26–March 4, 2004, 66.
2 Ken Johnson, "Peter Rostovsky: Deluge," *New York Times*, March 12, 2004, Art in Review sec.

LISA SANDITZ

(b. 1973, St. Louis, Missouri)
The Legend of Creve Coeur, 2003
Mixed media on canvas
42 × 48 in.

The legend of Creve Coeur is one of unrequited love. It is the site where two young lovers took their lives because familial and cultural differences forbade their love. Legend has it that when the two drowned in what would be called Creve Coeur Lake, the lake split into the shape of a broken heart, creve coeur in French. Now, this scrubby Midwestern lake is surrounded by suburban sprawl and notably flanked by an icon of modern-day fairy tale: a White Castle drive-thru.

Lisa Sanditz likes to joke that she is from Broken Heart, Misery, a.k.a. Creve Coeur, Missouri.[1] According to local lore, the town is named for the story of a Native American princess who fell in love with a French fur trader. When her lover abandoned her, she threw herself into the lake in despair. In the legend, the moment she died the lake formed the shape of a broken heart. To this day, the town uses this icon as a symbol.[2]

The artist divides her time between New York City and Tivoli, a small town in the Hudson River Valley. She is inspired by distinctively American landscapes, whether the majestic views of Hudson River School artists Frederic Edwin Church and Albert Bierstadt,[3] Ed Ruscha's gas stations,[4] or "lowbrow" images by Thomas Kinkade.[5]

Sanditz bases many of her works on locations she's visited on cross-country road trips, which she documents in photographs and sketches. She looks for substance and significance where the artificial meets the natural—where human "progress" has redefined the landscape. Back in her studio, she combines images from her travels with photos taken from the Internet. After completing several studies she begins to paint. While working she often listens to country music, where every song tells a story: narrative is the point of entry and departure for her. She discovers places that compel her; the act of painting and the finished work continue the unfolding tale.

In *The Legend of Creve Coeur*, the blue water of the lake has turned into a deep red upside-down broken heart. It is surrounded by hallucinatory purple trees and blue and red fireworks, and a ghostly white castle floats atop a red and green hill in the distance. Sanditz finds beauty and meaning in everyday places. Her colorful faux-naïf style conjures an uneasy peace melding the natural world, myth, history, and the forward march of modernity.

1 Hilarie M. Sheets, "Strip Malls in Paradise," *ARTnews* 106 (April 2007), http://www.crggallery.com/artists/lisa-sanditz/press/?article=17.
2 City of Creve Coeur, Missouri, website, http://www.creve-coeur.org/index.aspx?nid=220.
3 Sheets, "Strip Malls in Paradise."
4 Lisa Sanditz, artist statement, CRG Gallery website, http://www.crggallery.com/artists/lisa-sanditz/.
5 Barbara Pollock, "Marco Polo in Sock City," in Lisa Sanditz, Jonathan Franzen, and Barbara Pollock, *Lisa Sanditz: Sock City* (New York: CRG Gallery, 2008), 73.
6 Sheets, "Strip Malls in Paradise."

56

ANNA SCHACHTE

(b. 1976, Charleston, South Carolina)
Multi-Disciplinary Institution, 2007
Oil and enamel on canvas
57 x 57 in.

I always want my paintings to do more than one thing at a time, on many levels. In **Multi-Disciplinary Institution**, I wanted to create a space deep in perspective while warped and flattened by a grid of color—the pattern of light a disco ball throws on a room. Thinking of how art museums have taken to hosting dance parties and singles-mingle nights amidst their galleries, I imagined a vast space that hosts several layers of activity at once—the writhing floor of a gay nightclub, a runway fashion show with seated audience, straggling guests queuing up at the bar, and at the uppermost level, a single gallery-goer standing before a painting. I wanted to make "real" space that could believably house all of these events and at the same time give the viewer a feeling of hallucination. In the course of painting the hundreds of tiny figures and dots, I gave myself double-vision on more than a couple of occasions, though thankfully, only temporarily.

Anna Schachte paints futuristic locations and landscapes of her own invention. Her subject matter is not grounded in the world that exists, but in a slightly idiosyncratic parallel one. Light functions almost magically, depicting portals to another universe, multiple simultaneous shooting stars, and triangular rainbows. Schachte's bizarro-land is not always perfect—there are challenges there, such as ghosts or traffic. It is just different enough from our own to engage us and slowly but surely draw us in.

A pivotal moment in the artist's development came when she heard the painter Mary Heilmann (see p. 87) lecture on her practice of using pop songs and fabricated environments to connect with her audience.[1] Inspired to find new ways to interact and affiliate with her viewers, Schachte turned to her own love of nightclubs, raves, and dance parties. The communal experience of losing one's self in the rhythm of music and moving freely with the beat can be almost transcendent.

Multi-Disciplinary Institution invites us to a vast, impersonal party. Swirling glints from an invisible disco ball float around the cavernous space, illustrated by painterly dabs of yellow, orange, red, pink, and green. In varying shades of blue (royal, navy, aquamarine), Schachte creates a four-level environment empty of objects save for a few pale "paintings" at the uppermost level, but populated by hundreds of black-clad figures. The people sit, mill around, or writhe enthusiastically on the crowded dance floor at the lowest level. They are not distinguishable as individuals; they are anonymous participants signifying activity. When Schachte is working, she knows a painting is on the right track when she finds herself spontaneously dancing alone in her studio. The fun-loving inhabitants of the *Multi-Disciplinary Institution* might be seen as proxies for the artist, inviting us to join her on the dance floor.

1 Evan J. Garza, "Discotechnique," *Boston Phoenix*, June 11, 2009, http://thephoenix.com/boston/arts/84704-discotechnique/.

57

DANA SCHUTZ

(b. 1976, Livonia, Michigan)
Chris's Fireworks, 2002
Oil on canvas
42 × 47 in.

Initially, I was interested in painting sculpture because it has to deal with physics in a way that painting can take for granted. I started asking friends about sculptures they had made in undergraduate school. With beginners' sculpture, gravity seems stronger than usual—glue never holds, poles fall over, and projects fail, and even the successful ones get thrown out in the end. In my experience, people's early sculpture is usually heavily symbolic. When taken out of its original context, that symbolism becomes absurdist, defunct, or purely abstract. The sculpture becomes just a thing. I was interested in the object as a fictional artifact from a proposed real situation.

Dana Schutz found her calling at age 14 after attending Career Day at her high school in Livonia, Michigan. She filled out a questionnaire to determine her aptitudes, and learned that because of her love of the outdoors, physical activity, and working with her hands she would be best suited to a career as a bricklayer.[1] She decided instead to become an artist. By the next year she was painting for hours a day in her parents' basement and skipping classes and lunch hour to paint in a storage room at school.[2] Eventually she moved to New York, where she received an M.F.A. from Columbia University (and was finally allowed to paint in school).

Though Schutz occasionally sketches from life, almost all her work is inspired by a concept rather than by perceptual experience. Once she has an idea, it quickly blossoms into a fully formed fictional scenario, subject to its own rules and the whims of fate, which unfold as the paintings evolve. Schutz's subject matter includes sneezes, happiness, blindness, a post-apocalyptic series about the last man on earth (named Frank), lovers, death, and a mythical community of "self-eaters." Her oeuvre is almost entirely figural, and her style and use of color are as distinctive as her interest in absurd dystopias and the inherent drama of everyday moments.

Chris's Fireworks is a rare depiction of a friend's sculpture rather than the friend himself. The work's vibrant fauvist colors are typical of Schutz's palette, and delineate form with her customary energy and daring. The artist experiences color in a physical way—for her, a cool or cold color is painful and a warm one feels soft.[3] The brilliant red in *Chris's Fireworks* is scalding hot. Schutz is interested in the limitless possibilities of painting,[4] where gravity and perspective can be manipulated and opposing forces brought together. In *Chris's Fireworks* the artist has liberated her subject—a sculpture—from its three-dimensional solidity, transforming it with pointed brushy shapes that explode outward with such force that one can almost hear the bang.

1 Katrin Wittneven, "Welcome to Neverland," *Parkett* 75 (2005), 26–64.
2 Dodie Kazanjian, "Great Dana," *Vogue*, February 2006, 212–17.
3 Nicole Hackert, *Teeth Dreams and Other Supposed Truths* (Berlin: Contemporary Fine Arts, 2005), unpag.
4 Ibid.

58

SANDRA SCOLNIK

(b. 1968, Glen Falls, New York)
House II, 2003
Oil on wood panel
50 x 35 in.

All narratives involve some form of a journey or passage of time. It is a universal urge to translate our experiences meaningfully to one another. In a well-told story, the reader may enter the realm of the storyteller, take on the identity of the characters around whom the events take place. My paintings typically involve a personal narrative, as I have always used painting as a way to meditate on and process my life, relationships, and feelings. The journey through each painting hopefully creates a link between the viewer and artist, and I am keenly interested in this transaction between myself and the viewer. The empathic event, the willingness of the viewer to assume the story of another, to be able to imagine another world, time, or what someone else is feeling, is what connects us to one another as we pass from age to age.

Sandra Scolnik's detailed oil paintings are overtly autobiographical yet so impenetrably surrealistic that they defy clear narrative interpretation. She cites the artistic influence of 16th-century Sienese painting,[1] to which could be added the work of Henry Darger, Hieronymus Bosch, Frida Kahlo, and Shahzia Sikander.[2] She paints almost exclusively from her imagination, only occasionally consulting decorating magazines from the 1950s and '60s to refine her interiors. Her subject matter is her own likeness, represented many times within each painting as a series of avatars, often ranging in age from child/daughter through woman/mother to elderly grandmother. The replicants exist as if on stage sets, performing obscure tasks and chores, and acting out ritualistic plays of interdependence and connectedness.

The concept of the doppelgänger (which holds that every person has an identical counterpart somewhere in the world) stems from 19th-century German folklore. In its original meaning, to meet one's doppelgänger is a harbinger of one's own imminent demise.[3] From this perspective, Scolnik's alter egos can be seen as a confrontation with her own mortality or even her existence, raising questions about identity and selfhood. Not only is she asking, Who am I?,[4] she may also be asking, Do I exist only in relation to others, and if so, do I exist at all?

In the eerie psychodrama played out in *House II*, Scolnik's cast of selves occupy a claustrophobic pink doll's house set in a bucolic green landscape; cherubim and departed souls cavort in the heavens above. Also present are many of the artist's recurring motifs: red shoes, handbags, birds, trees, Christmas decorations, ghosts, and paintings within the painting. These seemingly unconnected details in Scolnik's dreamscapes identify them as realms dominated by themes of femininity, symbiosis, ritual, and decoration. Time seems to move forward and backward in her painting: though the house is decorated with a Christmas wreath and garlands, the grass is green and children and nude women frolic outside. The more details we notice, the more any linear logical reading is denied. What are the monkeys doing in the house? With each disorienting yet seductive visual conundrum, we take a step forward into the artist's world. Eventually, we construct our own meaning—a hybrid of Scolnik's pictorial feast and our own imagination. Perhaps the monkeys are there to keep an eye on the birds?

1 CRG Gallery press release, http://www.crggallery.com/printable.php?type=pr&id=53.
2 Jason Murison, "Surreal Servitude: Sandra Scolnik at the CRG Gallery," Reviews & Previews, *NY Arts Magazine*, July/August 2005, http://www.crggallery.com/artists/ sandrascolnik/press/?article=4; Matthew Biro, "Sandra Scolnik," *Contemporary Magazine* 75 (October 2005), http://www.crggallery.com/artists/sandra-scolnik/ press/?article=3; Piri Halasz, "(An Appropriate Distance) From the Mayor's Doorstep," *NY Arts* (June 2001), 55; Roberta Smith, "Paintings and Photos With Tales to Tell, Often About the Oddities of Growing Up," *New York Times*, December 5, 1997.
3 Biro, "Sandra Scolnick."
4 Tom Finkelpearl, "Kwangju Biennial in Curator's Gossip," *Flash Art* 33 (Summer 2000), 99.

59

SEAN SCULLY

(b. 1945, Dublin, Ireland)
Black Moon, 2006
Oil on canvas
84 × 72 in.

Sean Scully is best known for making abstract geometric stripes and grids, yet it is heartfelt thoughtfulness and deep humanism that inform his work. Born in Dublin, he grew up in a working-class South London neighborhood where he rebelled against his Catholic upbringing and societal pressures to conform, which he perceived as something between banality and a straitjacket. In college, he found an outlet in art and, at age 30, moved to New York to become an artist. Scully experiences the world as a difficult, uneasy place, and seeks to harness the transformative power of art making to create something irresistible out of the struggle. He describes his works as "pugnacious";[1] as though they are ready to throw a punch, but always on the side of right.

Scully works in oil, watercolor, pastel, and photography. Early in his career, he began to paint stripes, which gradually evolved into grids and checkerboards of gradated and contrasting color. Frequently he employs rectangular shapes that he tellingly refers to as "bricks."[2] While the grids could refer to anything from game boards to urban architecture, it is interesting to view them in the context of his most prolific series to date, *Wall of Light*. In 1983, on a beach in Zihuatanejo, Mexico, Scully responded to the light reflecting off the stacked stones of nearby Mayan ruins in a small watercolor of horizontal and vertical stripes and bars, in orange, blue, and green. Revisiting the work in 1998, he began to expand on the theme of walls, focusing on their structure and beauty as well as their symbolic embodiment of human accomplishment. In addition to Mayan ruins, he is inspired by the ancient hand-built stone walls of his native Ireland, Stonehenge's enigmatic monoliths, and the way light reflects off these enduring surfaces. Scully thinks of his "bricks" of color as building on mankind's past accomplishments and celebrating our evolution toward an improved civilization. He describes this optimistic yearning as a "romantic, idealistic philosophy" and hopes that it might help us locate, as he phrases it, "our better angels."[3]

Scully's method is a different kind of building. He begins by drawing on canvas with a piece of charcoal affixed to the end of a stick. This sketch is the foundation on which he lays out his bricks. Next, he slathers on layer after layer of oil paint from buckets, using two-inch-thick house-painting brushes. Applying wet paint on top of wet paint, he works quickly; if it is impossible to complete the work before the paint dries, he must carefully rework the colors at a later time. This challenge is evident in the careful brushstrokes visible on the finished surfaces. Between the edges of the smudgy forms we catch glimpses of the underpainting—the cement holding the bricks together. Scully's color is imbued with emotion. The dark blacks and grays in *Black Moon* convey a depth of melancholy that for the artist is a fundamental aspect of the human condition. Though he is strongly affected by tragic events in the world, he believes there is never a reason to lose hope. Like all his paintings, *Black Moon* is about the redemptive power of relationships; one stone resting on top of another or one human being leaning on another is cause for celebration. Scully's paintings are tough, tenacious, and compellingly beautiful. The artist once described the impulse behind his work as "trying to turn stone into light."[4]

1 Robert Enright, "A Dark But Vital Light: An Interview with Sean Scully," *Border Crossings* 103, http://www.bordercrossingsmag.com/issue103/article/16.
2 Craig Olsen, "Sean Scully," *Brooklyn Rail* (November 2006), http://www.brooklynrail.org/2006/11/artseen/sean-scully.
3 "The Personal Artistic Philosophy of Sean Scully," *Big Think*, http://bigthink.com/seanscully.
4 Grace Glueck, "A Mezzanine Done Over in Bricks, Evocative and Immediate," *New York Times*, September 29, 2006, http://www.nytimes.com/2006/09/29/arts/design/29scul.html.

60

AMY SILLMAN

(b. 1955, Detroit, Michigan)
Get the Moon, 2006
Oil on canvas
80 × 69 in.

Amy Sillman discovered her artistic calling by chance. Growing up in Chicago, she moved to New York in 1975 to study Japanese literature at New York University, intending to become a linguist. She enrolled in her first art class—introductory drawing—and found her vocation. She transferred to the School of Visual Arts, and after graduating worked in the art departments of various magazines before earning an M.F.A. from Bard College and becoming a full-time artist and teacher.

Sillman painted for many years before her work attained the mainstream recognition and critical praise it enjoys today. She has never chosen to do things the easy way and has resolutely introduced an intentional awkwardness into her compositions. She tackles monumental subjects such as sex, unhappiness, and death in a way that makes even her most beautiful paintings edgy. She has courted humor, often including smart visual gags, as in paintings such as *Me and Ugly Mountain* (2003), in which a small, sad-looking figure tows a transparent mountain behind her, filled with a jumble of figures, shapes, and colors. Sillman's more recent abstract works convey a different level of psychological exploration and unrest. Forms and lines are imbued with the weight of struggle and discontent, though there is a great deal of inherent strength that establishes the artist as a champion in her fraught visual narrative. She describes herself not as a contrarian but as a "scrapper."[1]

An accomplished draftswoman, Sillman sketches before and after making a painting, allowing her ideas to evolve continuously. When painting, she applies and scrapes away multiple layers of oil paint, adding and reducing simultaneously. While exploring opposing and complementary forms and marks on canvas, she remains deeply engaged with the physicality of painting—the brush acts as an extension of her arm as ideas flow through her. This embrace of tactile experience is evident in her complex and compelling surfaces, abounding with both sketchy and resolute brushstrokes.

Get the Moon marks a sea change in the artist's oeuvre, from pale pastel hues to a bright bold palette, and from a curvaceous, occasionally cartoonish style to a more linear abstraction in which figural elements are increasingly veiled. Here Sillman uses electric yellows and greens and bold vertical and horizontal strokes. The sole hint of representation is an elongated arm holding a smudgy black shape—perhaps a moon rock or a lump of coal, or something else entirely. Whether the title is a command or a promise is up in the air. The artist expresses her gutsy manifesto in a 'zine accompanying a recent gallery show:[2] "Long live 'difficult' art, difficult women & art that's not just made to sell! Long live the radical merging of mind and body! Think & Feel! Speak & Act!"

1 Ian Berry, "Ugly Feelings: A Dialogue with Amy Sillman by Ian Berry," in Ian Berry and Anne Ellegood, *Amy Sillman: Third Person Singular* (Saratoga Springs, N.Y.: Frances Young Tang Teaching Museum and Art Gallery at Skidmore College; Washington, D.C.: Hirshhorn Museum and Sculpture Garden, Smithsonian Institution, 2008), 13.
2 The exhibition was held at Sikkema Jenkins & Co. New York, N.Y., April 15– May 15, 2010.

61

TONY SWAIN

(b. 1967, Lisburn, Ireland)
Everything, 2007
Mixed media (newspaper collage,
ink, gouache)
17 × 11 in.

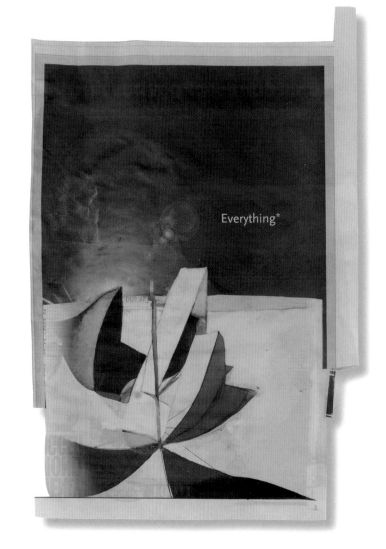

There is an interest in preservation. If the focus of newspapers is the topical, the "now," I feel compelled to locate the aspects of permanent intrigue or interest and to refocus upon them. To an extent I feel painting can provide a catchment for elements—even if only fragments—that would otherwise be lost. If painting is adapting the original forms, it is doing so in some way to guarantee their survival.

There are many strategies that facilitate the evolution of a painting. One method is overturning the original priorities of an image by pushing back what was intended as foreground and refocusing on what was originally incidental, another is imagining a continuation beyond the given image (extension of architectural forms, or mapping out the contours of an implied or suggested landscape). In a way, the newspaper as physical matter becomes analogous with these tenets or beliefs: frailty becomes delicacy, liability becomes an asset.

Tony Swain transforms arguably obsolete, mass-produced newspapers into delicate, intricate, and unique works of art. He first began to experiment with painting on newsprint by happenstance: in the habit of mixing paints on whatever useful bit of rubbish was nearby in his studio, chiefly piles of old daily papers, he became more and more interested in their properties as a medium.[1] Their fragility and impermanence appealed to him, and he was aesthetically compelled by the layout of photographs, headlines, and columns. Newspapers are engaging not only because they age quickly, providing interesting surfaces, but also because they are dated, adding another dimension to their temporality. It is a common criticism of newspapers that they are "yesterday's news"[2]—the artist creatively repurposes and redeems them.

In his studio, Swain spreads out the pages of the U.K. paper *The Guardian* and pores over them, cutting and rearranging their contents like a post-publication design editor. He reassembles new pages, never more than a few sheets at a time, gluing photographs and text together with a liberating disregard for the legibility of the original content. He then paints on these surfaces with a gentle, nostalgic palette—washy blues and yellows, brick reds, pale greens, and large amounts of charcoal and beige that mimic the yellowing paper and faded type of the sheets underneath.

The paintings are equal parts abstraction and the representation of quirky and fanciful environments that incorporate objects, scenes from nature, and architectural and geometric forms. Swain never paints figures—the realms depicted are surreal and apparently devoid of life.[3] His titles are suggestive of trippy newspaper headlines: *Intents Previous to Discovery*, *The Academy of Video Repair*, *The Watched Day*.

In *Everything*, Swain has transformed what appears to be an upside-down umbrella into a dreamlike moonscape, at once strange and familiar. Text from the verso side of the page shows through, and we can make out fragments of a sentence—something to do with a fire—and the faint, ghostly image of a man's face. The only word that is unmistakably legible serves as the title of the painting—"Everything"—standing for clarity yet illuminating nothing.

1 Isla Leaver-Yap, "Concrete Planes," *MAP* 11 (Autumn 2007), 42–46.
2 Martin Coomer, "News Style," *Big Issue*, May 18, 2009, 30.
3 Karla Black, "This Is a Ticket," in Mick Peter and Karla Black, *Tony Swain: Paintings* (Glasgow: Modern Institute; Cologne: DuMont Buchverlag, 2008), 7.

MARC SWANSON

(b. 1969, New Britain, Connecticut)
Untitled (Black Antler Pile), 2007–08
Styrofoam, adhesive, jet crystals
34 × 32 × 32 in.

The rhinestone sculptures began with wall-mounted deer heads and have evolved from there. I started experimenting with just the antlers several years ago, as a way to work with the same visual language in a more abstract and formal way. This sculpture is the largest such work I've made to date, with about 30 antlers in all. There's something about the perceived fragility of this work that appeals to me; it looks like the pile could collapse so easily. I also love that these symbols of virility are naturally shed by the animals each year, and I am able transform them and give them new life in my work.

Marc Swanson explores formal, conceptual, and material concerns through the lens of his personal history. Born in Connecticut and raised in New Hampshire, from an early age he hunted and fished with his ex-Marine father, and by adolescence had become an experienced outdoorsman. This rugged and traditional New England background informs his subject matter as much as his realization in his teens that he was gay and his later experience of life in San Francisco and New York City. These sharply contrasting environments are integrated in Swanson's work, which combines themes of the natural and man-made worlds while exploring society's conception of masculinity.

The artist has created his own language of symbols—the animals depicted in his work (often bucks or rams) are his "surrogates,"[1] through which he experiences emotion and, from the outside in, the human condition. In Untitled (Black Antler Pile) he has distilled the animals to the essence of their male identity, the antlers, to form a shape that is both beautiful and seemingly fragile. Despite Swanson's hunting past, no animals are harmed in the making of his work; he casts foam in molds made from previously deceased animals. He then covers them with sparkly rhinestones and crystals, a rite of decoration that throws into contrast the natural world and our haut monde regard of diamonds as the most beautiful and valuable gift we can give one another. His work synthesizes these dualities in an uneasy but striking union, just as the artist's own character has been shaped by the juxtaposition of his dissimilar life experiences.

Besides the bucks, rams, and antlers for which he is best known, Swanson has created animal skins out of T-shirts and wasps' nests out of blown glass. He has also constructed an elaborate basement environment for his most ambitious surrogate to date, the unsettling and strangely compelling Killing Moon 3 (Self-Portrait as a Yeti in His Lair) (2005). Casting his own face, hands, and feet, he built a life-size figure covered in white Mongolian lamb's wool, who crouches in a creepy, dimly lit subterranean urban dwelling filled with detritus ritualistically positioned in "primitive" arrangements. The artist spent weeks combing the streets of Brooklyn and Queens to find just the right urban debris for his Yeti. He identified so strongly with his creation that he was moved to say, "I am the Yeti and the Yeti is me."[2] It is a loving portrait of alienation and self-soothing, human emotions expressed through a mythical Himalayan beast.

1 Public Art Fund, "Marc Swanson: Fits and Starts," http://www.publicartfund.org/pafweb/projects/04/metrotech/semprecious_swanson_04.html.
2 João Ribas, "Emerging Artists: Marc Swanson," artinfo.com, November 15, 2005, http://www.artinfo.com/news/story/1568/emerging-artists-marc-swanson/.

63

JUAN USLÉ

(b. 1954, Santander, Spain)

Entre dos tierras, 2006

Vinyl dispersion and dry pigment on canvas

18 × 12 in.

On the plane, my daughter Vicky asked insistently, "Where are we now, Dad?" The lit sky was intense, and she, at 8 or 9 years old, was crossing the Atlantic for the first time without sleep.

From the window, the colors of an ardent dawn refused to abandon us. "Without a doubt, we are over the ocean," I responded. But the sky was so intensely red, that she, as if in awe, asked many more times.

In the end, I had only one answer, "Between two earths, we are between two earths."

It is true that many times when I paint I have sensations similar to traveling. I even think of places whose names I desire not to know, nor fix, nor even attempt an adjusted image, or a sharp one, but more to evoke a vision in paint where the image can be at the same time a look and a question—a residue of its dispersion.

The image now grows. Ordered in a sequence, the brushstrokes, almost identical at first, slowly develop differently, aiming towards something more complex, difficult to grasp. Like an oration that has an unclear beginning, they direct themselves, without a doubt towards an encounter.

In succession, as in an ordered vignette, of an almost blind image, the lines evoke vibration, pulse and movement, displacement and mutation. From the initial silence they announce a process, an experimental transit.

On occasion I have had to explain and also ask myself why I live in New York; also how I felt, as a lover of nature, in a large city such as this. Lightness, I used to answer, lighter, with one foot on either side of the Atlantic, breathing above an imaginary bridge constructed by dreams and recollections, ambition and memory.

Maybe from that, this painting titled **Entre dos tierras** should have been blue, a deep profound blue, as appears in works from the series **Los ultimos sueños del Capitán Nemo**, or as in **Voice**, or as in many others. But I decided that red should be the color of its background and sky for dreams, to go across space and be crossed, like we cross many times, traveling from one side of the Atlantic to the other.

JUAN USLÉ

Juan Uslé exuberantly addresses dualities in his work: nature and culture, activity and calm, narrative and abstraction. Born in Santander to a family of modest means, he grew up in the northern Spanish countryside near the small town of Saro. His first experience of art, at age five, was the glimpse of a painting of the founder of the convent where his parents worked. It was an overwhelming experience for the sensitive and visually responsive child; as he gazed at the portrait, the subject's eyes seemed to follow him wherever he moved.[1] He quickly left the room and never returned, but the impression of art as an interactive experience of seeing and being seen stayed with him. The memory not only seeded his respect for the power of perception, but established his dialectic approach to his own work and that of others.

After having established a career as an artist in his native Spain, Uslé moved to New York in 1987, knowing no one and speaking no English. He was immediately seduced by the city's energy—the confluence of the dirty streets and harsh metropolitan environment with the magical and moving encounters with strangers that are part of everyday urban life. His work changed from a lyrical and flowing style to reflect the grids, beams of light, noise, and hustle around him. Getting lost in the subway gave rise to the idea that the city had a mind and will of its own that he could either struggle against or revel in.[2] True to his open nature, he wholeheartedly accepted the city's pulse as his own. Now dividing his time between Saro and New York, his work is equally informed by the stillness of his native countryside and the speed and vitality of his adopted home.

Uslé's use of color and form is as intuitive as his response to the world. He does not work representationally or conceive of a predetermined outcome for his paintings. Instead, he responds to forms and colors as they present themselves and engages in a dialogue involving forces in the world, his internal perceptions and feelings, and the voice of the work itself as he layers on translucent veils of color. The result often resembles a tapestry,[3] an apt analogy for this interweaving of external and internal forces. His technical virtuosity was in part acquired through necessity: as an art student he could not afford commercial paints and learned how to create his own colors using dry pigment, vinyl, acrylic, color dispersions, and oil.[4]

The brilliant red of *Entre dos tierras* depicts an hours-long sunrise on an overseas flight, and one can interpret the ribbons of color as a series of horizons, sunrises, sunsets, and the moments in between, experienced during the artificial cycle of a traveler's disrupted time. The title, which can be translated as *Between two lands*, describes where the artist spends his time, physically and psychologically. Just as all of Uslé's environments influence him, we may allow ourselves to be influenced the same way by this work. As the nun's eyes followed the artist as a young boy, we walk around this small painting and gaze into it, engaged not by eyes staring back at us but by the poignant evocation of places both near and far. In a sense, all people are between one world and another, and Uslé's layers bring us to an awareness of this transience. Yet his painting is not a warning but a celebration—an invitation to be alert and open to life itself.

1 Marianne Hartigan, "A Convent Education," *Sunday Tribune* (Dublin), September 12, 2004.
2 Hilarie M. Sheets, "Thinking Outside the Grid," *ARTnews* 11 (December 2004), 123.
3 David Pagel, "Juan Uslé's miniatures make a big impression," *Los Angeles Times*, June 6, 2008, http://www.latimes.com/entertainment/news/arts/la-et-galleries6-2008jun06,0,4126691.story.
4 Ben Luke, "Juan Uslé," *Art World* 2 (December 2007–January 2008), 98.

ALISON VAN PELT

(b. 1963, Los Angeles, California)
Agnes Martin (Study), 2001
Oil on canvas
30 x 24 in.

This painting was done as a study for a 9-x-7-foot portrait of Agnes Martin that was part of a series of paintings titled **The Women**. The 14 paintings in that series, all 9-x-7 feet, were of great women artists from last century, including Louise Bourgeois, Claude Cahun, Louise Nevelson, Alice Neel, Georgia O'Keeffe, Lee Krasner, Elaine de Kooning, Käthe Kollwitz, Frida Kahlo, Eva Hesse, and, of course, Agnes Martin. They were shown at The Dayton Art Institute and the Fresno Art Museum. The larger portrait of Agnes Martin was my first attempt at a white on white painting. This seemed to fit her, as her work was so light and subtle itself. Initially, in the smaller portrait I was trying to lighten up the palette. With that piece I learned that the shades of white to gray had to be so subtly different (to get the effect of a white on white painting) that they would have to be virtually indistinguishable on the palette. I did another, smaller portrait of Agnes Martin that she herself owned.

Alison Van Pelt's subjects have included birds, boxers, celebrities, spiritual leaders, politicians, and artists. The women artists in this series are icons of success in the male-dominated 20th-century art world whom Van Pelt selected by examining her connection with their work. While she has said that this series represents a kind of idolatry for her,[1] it also comprises unusually personal portraits. For the most part, she depicts the women in their later years (except for Hesse and Kahlo, who died young) to glorify the wisdom and experience etched in the lines and character of their faces, rather than bowing to the societal convention of celebrating only the young and beautiful years of even the most brilliant women.[2]

When beginning a painting, Van Pelt finds an image or an array of images that captures a subject to her liking. She then makes a series of studies on wood, paper, or canvas, trying out various sizes and experimenting with color and surface texture. As these studies evolve, she paints a traditional portrait in her characteristically limited palette. While the oil paint is still wet, she uses a dry brush to blur, striate, and gradually destroy the near-perfect image she painstakingly constructed only minutes before. This deliberate obfuscation gives the paintings a haunting, almost holographic quality—as though we were looking through a veil of flat, bright color to plumb the depths beneath. Though her subjects' faces are clearly discernible from a distance, on closer view they seem to disperse into a fog, leaving behind only the subtle variation of color and light playing across the surface. This disappearance evokes the ephemeral humanity of the subject: this is a person who existed or still exists, yet who will inevitably slip into the mists of history with the passage of time.

Agnes Martin (Study) is a painting made before the erasure of Martin's features is complete. In the last work in the series, Martin has disappeared almost entirely into a white-on-white field, like the ghost of an angel. In this study, we see hints of the grids that represent Martin's signature style, as well as the monochromatic color scheme and lightness of touch that the two artists share. In her paint handling, too, Van Pelt pays homage to the older artist's style. Despite these similarities, Van Pelt's work exists in a different, though equally mystical, place from Martin's abstractions, hovering between representation and abstraction, motion and stasis, and, ultimately, the present and history.

1 Jim Dicke II and Alex Nyerges, introduction to Michael K. Komanecky, *Alison Van Pelt: The Women* (Dayton: Dayton Art Institute, 2004), 8.
2 Michael K. Komanecky, "Interview in Alison Van Pelt's Studio, New York, January 2003," in Komanecky, *Alison Van Pelt*, 12.

65

TAM VAN TRAN

(b. 1966, Kontum, Vietnam)
Sex with Alien Armies, 2001
Acrylic on canvas
30 x 64 in.

sex with alien armies comes out of a sense of isolation. i see it as an isolation diagram, a certain kind of infraction, song accompaniment to silence within space. the lines and filament in the painting are like a spinadoodle while waiting.

the experience of coming over from vietnam and the act of being lost, waiting . . . waiting to be picked up in a boat or a plane or ship and being discovered by loved ones and experiences of flying over oceans from vietnam to the us. these experiences that came from the vietnam war have had an influence on these paintings.

edward hopper paintings of this kind of loneliness is what most aliens experience.

i also made them in downtown la having moved into a studio in an isolated industrial neighborhood. having just come from nyc to la and seeing the burning of la from a roof in hollywood during the rodney king riot, i think this also had an influence.

there is a reference to insects, nature, computers, all of it a filigree of information, like spiders who are practical doodlers of specific architectural form. also, besides the reference to hopper, there is a kind of relationship to earlier american surrealist-inspired painters such as charles seliger.

the ground is first gessoed, sanded, then sprayed with an air gun, then worked over with a fine sable brush.

Sex with Alien Armies (detail)

Tam Van Tran emigrated to the United States from Vietnam in 1975 at age nine, just before the fall of Saigon and the end of the war. He and his siblings left their parents behind, and grew up in Denver, Colorado, with an adoptive family. This early displacement became the catalyst for Van Tran's investigation into the concept of otherness.[1] What was originally a personal exploration of his immigrant experience grew to encompass other dichotomies—physical vs. mental travel, man vs. machine, organic vs. inorganic matter, earth vs. space, macro- vs. microscopic scale. He is inspired by nature, especially its impermanence and cycles of life and decay[2] (even growing his own materials, such as beets, for later use as color). He is equally compelled by manmade technology such as virtual reality and video games. Science fiction is of particular interest to the artist,[3] because he came to the United States at such a young age, a stranger in a strange land. In science fiction, the protagonist is often taken to a faraway, hostile environment and must enter the alien culture through skill and bravery alone.

Van Tran is known for his aerial landscapes, which resemble topographic diagrams or surveillance photographs generated by a rogue satellite. He studies maps, city blueprints, and plans of battle scenes to gain inspiration for his overlaid color grids. Once the grids are mapped out in overlapping synchronization on his canvas, he fills in selected circles and rectangles with vibrant bursts of color. Although he does not make preliminary sketches, this is a time-consuming process. He works on up to four canvases, intermittently, at a time. Though each painting is painstakingly handmade by the artist, it often resembles nothing so much as a bizarre version of technical circuitry.

The background of *Sex with Alien Armies* is a dusky reddish brown, evoking either fertile soil or rusted metal. A delicately detailed network fans out across the surface, overlaid with Van Tran's trademark geometric forms and blocks of color. The resulting composition could be a wave breaking on Mars, an urban planning map for cyborgs, or a web made by a robotic spider.

1 Terrie Sultan, *Tam Van Tran: Psychonaut* (Houston: Blaffer Gallery, the Art Museum of the University of Houston, 2006), 10.
2 Suzanne Hudson, "Tam Van Tran," *Artforum* 44 (January 2006), 224.
3 Nicholas Baume, "Tam Van Tran," *Supervision* (Boston: Institute of Contemporary Art, Boston, 2006).

66

TOMMY WHITE

(b. 1970, Kingsville, Texas)
Self-involved, 2008
Oil on canvas
95 × 75 in.

Tommy White's dark and surrealistic oil paintings are a curious hybrid of styles descended in equal measure from Salvador Dalí and Francis Bacon. His imagery of the human body is not so much fragmented as segmented. The bodies depicted are eternally in flux, neither becoming nor disintegrating, as though arrested along their evolutionary journey. White's backgrounds are opaque and ambiguous, pushing the pale amorphous figures forward out of the picture plane. This outward thrust is emphasized by his uneven application of paint—it is either washed on thinly as a glaze, or clumped on so heavily that it verges on three-dimensionality, an effect increased by the little tufts of hair that frequently emerge from the paintings' surfaces.

White originally worked in photography and sculpture as a way to map out and inform his painting, but he has since exhibited all three media together. His mixed media sculptures depict humanoid fragments, sometimes partially sheathed in clothing remnants and occasionally hanging from the ceiling to align with the standing viewer. White's photographs are of the sculptures, shot and cropped at odd angles and further obscured with ink and paint. As always, he depicts the human body in transformation, though from what to what is unclear.

In *Self-involved*, the naked torso of a man emerges from a gastropod-like shell, coiling around its stony exterior as if devoid of any endoskeleton. Something appears to have gone drastically wrong with his creation, or self-becoming, as there are several woundlike round holes in his shell and a golden yellow liquid seeps out from underneath him. This disgorging is a recurring theme in White's work, though often the excretion is of a more scatological nature.[1] The mollusk-man inhabits an unwelcoming environment: his world is mostly the charcoal gray of post-apocalyptic ash, apart from a spattering of drops of the golden liquid which could be either spraying out of or raining down on him. The effect is deeply unsettling and ambiguous, though not without hope. Could this be the beginning of a new race, a nebulous dawn for mankind?

1 Suzanne Hudson, "Tommy White," *Artforum* 45 (April 2007), 276–77.

67

SUE WILLIAMS

(b. 1954, Chicago Heights, Illinois)
Springtime for the RNC, 2005
Oil on acrylic on canvas
96 × 104 in.

This was painted at the time of the rise in popularity [or public relations] of the far right Republican Party. Unfortunately, now this could also be titled **Springtime for the DNC**, with few exceptions. The "flowers" are very wrinkled and tightly puckered, ready to expand without warning. The many wrinkles are also an excuse for me to paint long, uninterrupted brushstrokes. Or maybe it's just flowers on a spring day. This is one of my favorite paintings.

Sue Williams deplores injustice and hypocrisy. During her decades-long career, her targets have included domestic abuse, the violation of women's rights, violence of any kind, political posturing, and the machinations of war. She has addressed these concerns through painting, drawing, and occasionally sculpture. Her drive to champion the victim has roots in her own experience: she endured domestic abuse for years.[1] Her early works attracted attention because of their brutal subject matter as much as their deft execution. Though her work, even at its most discomforting, has always had elements of wit, it can be difficult to look at without squirming. As her practice progressed, she moved from making figural paintings with text to an abstract style reminiscent of Willem de Kooning's late works.[2] This abstract style was a clear precursor to her work today, which seamlessly melds abstraction with representation, while embracing topicality and emphatically reminding us that Williams has something to say.

Though the artist sometimes has help preparing her canvases, she paints them alone. The preparation involves eight or nine layers of gesso, which are sanded down evenly, followed by two or three layers of white acrylic applied with rubber brushes and spatulas for a smooth, even finish. When the canvas is ready, Williams uses Japanese sable brushes to paint and paper towels to erase, in a process that can last days or even weeks. She does not make preliminary sketches and while she often starts with an idea in mind, she remains open to accident and diversion. Quoting the mantra of the well adjusted, she explains: "One thing leads to another."[3]

Springtime for the RNC is a vibrant, lyrical image containing a sly, bawdy wink, a political statement, and a song of protest hidden in plain sight. The work's title is a play on the title of a song in the Mel Brooks comedy *The Producers*—"Springtime for Hitler." The film is about two producers who concoct a fraudulent scheme to oversell backing for a musical they determine will flop, allowing them to keep all the money themselves. Their plot backfires when the offensive musical is perceived as satire and becomes a hit. The Catch-22 is that, though the audience laughs, the tasteless atrocity portrayed was never a joke at all. In Williams's painting, the restricted palette is charming—bubblegum pink shapes float on a lime-green background, clustering and merging like a biomorphic Lilly Pulitzer print. Her deft handling of curvilinear forms hints at the anatomical—the flowery forms could be intestines, or something naughtier. If we are initially seduced by the pleasant colors, lacy forms, and appealing composition, the title alerts us to our gullibility. Something darker is at play here, and though we may or may not be in on it, Williams makes sure we don't miss it. If we are not all culpable, we must at least be aware.

1 Roberta Smith, "Up and Coming: Sue Williams: An Angry Young Woman Draws a Bead on Men," *New York Times,* May 24, 1992.
2 Barry Schwabsky, "Painting in the Interrogative Vein: The Recent Work of Sue Williams," *Border Crossings* 111 (August 2009), http://www.bordercrossingsmag.com/issue111/article/2679.
3 Michael Kimmelman, "In a Cheerful Groove, With a Plan and Serendipity," *New York Times,* December 28, 2001, E41.

68

CLARE WOODS

(b. 1972, Southampton, England)
Monument Way, 2002
Enamel on aluminum
64 × 96 in.

The photograph I used to make the image for the painting **Monument Way** was taken randomly, at night, using a flash to capture the bright and reflective surfaces of pockets of scrub. The image is not only obscured by nightfall but by snowfall. The work contrasts with the indeterminable and desolate locations I have been photographing and painting in Britain. The painting is grounded in the reality of the landscape but has the endless possibilities of abstraction.

Clare Woods grew up in the English countryside, quite comfortable with the isolation and the pitch-black darkness of rural night. After moving to London for graduate school, however, she became accustomed to the city lights and found herself deeply unnerved when she returned to her childhood home. Using fear as her starting point, she challenged herself to explore this unease in her work.[1] Now, the artist roams the outdoors, often at night, with her camera, photographing apparently mundane, remote pockets of bracken and woods. She seeks the places where nature scrappily struggles to life in the midst of postindustrial desolation.

Monument Way shows her sensitive handling of this seemingly unfriendly subject matter. She has transformed the messiness of nature—an overgrowth of tangled brush and gangly trees—into a model of tasteful harmony, without losing any of the inherent mystery of the forest. *Monument Way* is tonally cold yet disarmingly seductive in its formal elegance. The dialectic between the darkest and lightest of the leaf and branch forms is resolved in a subtle medley of grays and beiges. The resulting pattern has a rhythmic grace that draws the viewer's eye into a visual dance across the painting.

Once Woods has selected a source photograph, she projects it onto canvas or a sheet of aluminum and sketches it as a line drawing. She then fills in the delineated areas with enamel paint and gloss, sometimes pouring paint directly onto the surface.

This pouring method invites comparison with Jackson Pollock's,[2] though the resulting images are more reminiscent of those of Gary Hume. She has an unusual practice of painting the foreground before filling in the background, effectively blurring our visual distinction between the two. The artist's apprehension about her subject would be almost invisible, given the glossy insouciance of her paintings, if her titles did not open a window into a distinctly eerie element: they are often taken from the names of defunct orphanages or insane asylums.[3] Armed with this knowledge, we catch glimpses through the visual delight of Woods's paintings into a darker world, where things go bump in the night.

1 Clare Dwyer Hogg, "Living Colour," *Independent* (London), September 9, 2006, 47.
2 Martin Coomer, "Clare Woods: Deaf Man's House," *Art Review* 5 (November 2006), 194.
3 Dale McFarland, "Clare Woods," *Guardian* (London), March 22, 2001, http://www.guardian.co.uk/becksfutures2001/story/0,,461377,00.html.

69

LISA YUSKAVAGE

(b. 1962, Philadelphia, Pennsylvania)
G. B. Posing, 2001
Watercolor with gouache highlights on paper
10 1/4 x 7 in.

Lisa Yuskavage's subjects are almost exclusively women, most often variations on the time-honored tradition of the female nude. Her inspiration comes from a wide range of high and low art: the paintings of Tintoretto, Caravaggio, de Chirico, and Philip Guston, Degas's monoprints, Shirley Temple movies, and Bob Guccione's lad-mag *Penthouse*. Her inclusiveness may arise from the contrast between her background and her ensuing life experiences. She grew up in a working-class neighborhood in Philadelphia (her father drove a delivery truck) and eventually, on the strength of her talent and drive, attended Yale University and traveled through Europe studying art. This gutsiness has served her well; her oeuvre has positioned her as a polemical figure—she has been accused of everything from slavish catering to the patriarchy to radical feminism. Her work often sparks controversy for its explicit, exaggeratedly pneumatic female forms and for her borderline kitschy infantilization of women. Despite their outsize proportions, her subjects often appear to be young girls. Though she readily explains that she is something of a feminist, as an artist she is conjuring a set of possibilities that could contradict her work's initial read.[1] It stems from a personal and psychological space of discomfort, culpability, and identification[2] having more to do with women's self-image and sense of worth[3] than with men's vision of what a woman should look like or be.

Yuskavage discovered early in her career that painting is, for her, a solo activity, so in advance of her studio time she stages elaborate photo shoots with live models in order to map out her compositions. She also makes small sculptures of figures with clay to experiment with positioning and lighting. She then spends long hours in her studio alone—without even a telephone—working her way through drawings, watercolors, and paintings. Painting is an emotional experience for Yuskavage, and she has often mentioned her tendency to anthropomorphize color and shape as women—a yellow-hued painting will evolve into a portrait of a blonde, a red one into a redhead.[4]

In *G. B. Posing*, by restricting the palette to shades of salmony orange, the artist not only imbues the watercolor with warmth and a kind of gentleness, but also directs our attention to its curvilinear forms and composition. The ruffled blouse is echoed in the soft drapery behind the figure and the waves of her hair. A vase of flowers and a teapot appear just to her right, a knowing wink toward traditional feminine pastimes of flower-arranging and tea-parties. "G. B." appears pensive, her eyes dark pooling dots, her mouth an inscrutable wash. Her hands are demurely folded in a ladylike pose. The work, studded with a few bright points of light, seems to glow from within.

1 Robert Enright, "The Overwhelmer: The Art of Lisa Yuskavage," *Border Crossings* 103 (August 2007), http://www.bordercrossingsmag.com/issue103/article/15.
2 Christian Viveros-Fauné, "Cursed Beauty: The Painting of Lisa Yuskavage and the Goosing of the Great Tradition," *Lisa Yuskavage* (Mexico City: Museo Tamayo, 2006), 63.
3 Peter Schjeldahl, "Girls, Girls, Girls," *New Yorker*, January 15, 2001, 100–01, and Jayson Whitehead, "What Kind of Thing Am I Looking At? An Interview with Painter Lisa Yuskavage," *Gadfly* (April 1998), http://www.gadflyonline.com/archive/April98/archive-yuskavage.html.
4 "Interview: Chuck Close Talks With Lisa Yuskavage," *Lisa Yuskavage* (Santa Monica: Christopher Grimes Gallery, 1996), 31.

70

LISA YUSKAVAGE

(b. 1962, Philadelphia, Pennsylvania)
Elizabeth on a Pedestal, 2001
Watercolor with gouache highlights on paper
10 1/4 × 7 in.

Elizabeth on a Pedestal is an example of Yuskavage's more racy subject matter. "Elizabeth" is a nymphet perched with delicately angled hips, clad in scanty underthings, solipsistically examining her own arm. Her upturned button nose is a recurring Yuskavage icon—her women are unfailingly cute— yet there is beauty there too. The mannerist pose artfully conceals the figure's breasts. She is adorned with a corsage on her left wrist and her right arm appears to end in a teacup. Her stance invites a certain measure of ogling, but she conceals even as she reveals, and, armored as she is with flowers, feathers, and a teacup, the viewer responds to her sweetness and vulnerability rather than to her teasing. The artist has said that all of her works are to some extent self-portraits. *Elizabeth on a Pedestal* conveys the full range of Yuskavage's preoccupations—desire vs. voyeurism, male vs. female ways of looking, and most of all, the delicate balance of light, composition, and subject matter. Keep looking, she seems to say, there is more here than meets the eye.

JOHN ALEXANDER
Livingston, Jane, Alison de Lima Greene, and Robert Hughes.
John Alexander: A Retrospective. Houston: Museum of Fine Arts,
Houston, 2008.

GREGORY AMENOFF
Wakefield, Trevor. *Gregory Amenoff: Facing North*. New York:
Alexandre Gallery, 2007.

LINDA BESEMER
Yau, John, and David Batchelor. *Linda Besemer*. Santa Monica:
Angles Gallery; New York: Cohan Leslie and Brown, 2002.

MEL BOCHNER
Bochner, Mel, and Yve-Alain Bois. *Solar System & Rest Rooms:
Writings and Interviews, 1965–2007*. Cambridge, Mass.: MIT
Press, 2008.

Burton, Johanna, et al. *Mel Bochner–Language, 1966–2006*.
Chicago: Art Institute of Chicago, 2007.

MARK BRADFORD
Bedford, Christopher. *Mark Bradford*. Columbus, Ohio:
Wexner Center for the Arts, Ohio State University, 2010.

Foster, Carter E. *Neither New nor Correct: New Work by Mark
Bradford*. New York: Whitney Museum of American Art, 2007.

Gaines, Malik, Ernest Hardy, Philippe Vergne, and
Mark Bradford. *Mark Bradford: Merchant Posters*. Aspen:
Gregory R. Miller / Aspen Art Press, 2010.

CECILY BROWN
Ashton, Dore. *Cecily Brown*. New York: Rizzoli International
Publications, in association with Gagosian Gallery, 2008.

Cotter, Suzanne, and Caoimhin Mac Giolla Leith. *Cecily Brown:
Paintings*. Oxford: Modern Art Oxford, 2005.

Drucker, Johanna. *Cecily Brown: Paintings, 2003–2006*. New
York: Gagosian Gallery, 2006.

Eccher, Danilo. *Cecily Brown*. Rome: Museo d'Arte
Contemporanea, 2003.

Fleming, Jeff, et al. *Cecily Brown*. Des Moines: Des Moines
Art Center, 2007.

FRANCESCO CLEMENTE
Dennison, Lisa, et al. *Clemente*. New York: Solomon R.
Guggenheim Museum, 1999.

ED COHEN
Leader, Darian. *Ed Cohen*. New York: Jeannie Freilich
Contemporary, 2008.

Ostrow, Saul. *Ed Cohen*. New York: Jeannie Freilich Fine Art,
2006.

ANDY COLLINS
Oliva, Achille Bonito. *Andy Collins*. Modena, Italy: Emilio Mazzoli
Galleria d'Arte Contemporanea, 2001.

WILL COTTON
Hindry, Ann. *Will Cotton: Paintings 1999–2004*. Paris: Galerie
Daniel Templon, 2006.

JOHN CURRIN
Fleming, Jeff. *John Currin: Works on Paper*. Des Moines: Des Moines Art Center, 2003.

Rosenblum, Robert, and Staci Boris. *John Currin*. With interview by Rochelle Steiner. Chicago: Museum of Contemporary Art; London: Serpentine Gallery, 2003.

Vander Weg, Kara, with Rose Dergan, eds. *John Currin*. With essays by Norman Bryson, Alison M. Gingeras, and Dave Eggers. New York: Gagosian Gallery, 2006.

TOMORY DODGE
Ryan, Jeffrey. *Tomory Dodge*. Los Angeles: ACME.; New York: CRG Gallery, 2008.

PETER DOIG
Nesbitt, Judith, ed. *Peter Doig*. With contribution by Richard Shiff. London: Tate Publishing, 2008.

Searle, Adrian. *Peter Doig*. New York and Cologne: Michael Werner Gallery, 2002.

Searle, Adrian, Kitty Scott, and Catherine Grenier. *Peter Doig*. London: Phaidon Press, 2007.

INKA ESSENHIGH
Clearwater, Bonnie. *Inka Essenhigh: Recent Paintings*. North Miami, Fla.: Museum of Contemporary Art, North Miami, 2003.

ERIC FISCHL
Danto, Arthur C., Robert Enright, and Steve Martin. *Eric Fischl: 1970–2007*. New York: Monacelli Press, 2008.

Hentschel, Martin, ed. *Eric Fischl: The Krefeld Project*. Krefeld: Museum Haus Esters, 2003.

LOUISE FISHMAN
Deitcher, David. *Louise Fishman*. New York: Cheim & Read, 2006.

CAIO FONSECA
Millet, Teresa, Daniel Kunitz, and Caio Fonseca. *Caio Fonseca*. Valencia: Institut Valencià d'Art Modern, 2003.

Serwer, Jacquelyn D. *Inventions: Recent Paintings by Caio Fonseca*. With interview by Karen Wright. Washington, D.C.: Corcoran Gallery of Art, 2005.

MARK FRANCIS
Dyer, Richard, Francis McKee, and James Peto. *Mark Francis*. Dublin: Dublin City Gallery, The Hugh Lane, and Lund Humphries, 2008.

BERNARD FRIZE
Hoffmann, Jens. *Bernard Frize: Longues lignes (souvent fermées)*. London: Simon Lee Gallery; Paris and Miami: Galerie Emmanuel Perrotin, 2007.

MARY HEILMANN
Armstrong, Elizabeth, Johanna Burton, and Dave Hickey. *Mary Heilmann: To Be Someone*. Newport Beach, Calif.: Orange County Museum of Art in association with Prestel Publishing, 2007.

SHIRAZEH HOUSHIARY
Gooding, Mel. *A Suite for Shirazeh Houshiary*. London: Lisson Gallery, 2008.

BRYAN HUNT
Balken, Debra Bricker. *Bryan Hunt: Sculpture + Drawings*. Philadelphia: Locks Gallery, 1998.

Sandler, Irving. *Bryan Hunt*. New York: Mary Boone Gallery, 1997.

BILL JENSEN
Hinton, David. *Bill Jensen*. New York: Cheim & Read, 2010.

Yau, John. *Bill Jensen: Paintings*. New York: Cheim & Read, 2007.

JUN KANEKO
Brown, Glen. *Jun Kaneko.* Sedalia, Mo.: Daum Museum of Contemporary Art, 2002.

Peterson, Susan. *Jun Kaneko.* With foreword by Arthur C. Danto. London: Laurence King Publishing, 2001.

ALEX KATZ
Ratcliff, Carter, Iwona Blazwick, and Robert Storr. *Alex Katz.* London: Phaidon Press, 2005.

Sandler, Irving. *Alex Katz: A Retrospective.* New York: Harry N. Abrams, 1998.

Tuite, Diana. *Alex Katz: Subject to Reversal.* Chicago: Richard Grey Gallery, 2008.

PER KIRKEBY
Borchardt-Hume, Achim. *Per Kirkeby.* With an essay by Richard Shiff. London: Tate Publishing, 2009.

Gohr, Siegfried. *Per Kirkeby: Journeys in Painting and Elsewhere.* Ostfildern, Germany: Hatje Cantz Verlag, 2008.

Shiff, Richard, and Robert Storr. *Per Kirkeby: Louisiana 2008.* Edited by Poul Tojner and Ulrich Wilmes. Copenhagen: Louisiana Museum of Modern Art, 2008.

DAVID KORTY
Kushner, Rachel. *David Korty.* London: Sadie Coles HQ, 2008.

MARILYN MINTER
Burton, Johanna. *Marilyn Minter.* New York: Gregory R. Miller, 2007.

KATY MORAN
Melissa Gronlund. *Katy Moran: Paintings.* Middlesbrough, England: mima [Middlesbrough Institute of Modern Art], 2008.

Hughes, Sarah. *Katy Moran.* Cornwall, England: Tate St. Ives, 2009.

TAKASHI MURAKAMI
Schimmel, Paul, et al. *Murakami.* Los Angeles: Museum of Contemporary Art, Los Angeles; New York: Rizzoli International Publications and Kaikai Kiki New York; Tokyo: Kaikai Kiki Co., 2007.

YOSHITOMO NARA
Chambers, Kristin, et al. *Yoshitomo Nara: Nothing Ever Happens.* Cleveland: Museum of Contemporary Art Cleveland, 2008.

Chiu, Melissa, and Miwako Tezuka. *Yoshitomo Nara: Nobody's Fool.* New York: Abrams Books and Asia Society, 2010.

TODD NORSTEN
Todd Norsten: *The Masterworks.* New York: Cohen and Leslie, 2008.

Vergne, Philippe. *Todd Norsten: Safety Club.* Minneapolis: Midway Contemporary Art, 2007.

THOMAS NOZKOWSKI
Yau, John. *Thomas Nozkowski: Recent Work.* New York: PaceWildenstein, 2008.

RICHARD PATTERSON
Morgan, Stuart. *Paintings by Richard Patterson.* London: Anthony d'Offay Gallery, 1997.

PHILIP PEARLSTEIN
Storr, Robert. *Philip Pearlstein since 1983.* New York: Harry N. Abrams in association with Robert Miller Gallery, 2002.

Worth, Alexi. *Philip Pearlstein.* New York: Betty Cunningham Gallery, 2005.

RICHARD PRINCE
Spector, Nancy, et al. *Richard Prince.* New York: Solomon R. Guggenheim Foundation, 2007.

DAVID RATCLIFF
Nickas, Bob. *defect's mirror.* New York: Team Gallery, 2008.

LISA SANDITZ
Franzen, Jonathan, Barbara Pollock, and Lisa Sanditz.
Lisa Sanditz: Sock City. New York: CRG Gallery, 2008.

DANA SCHUTZ
Hackert, Nicole. *Teeth Dreams and Other Supposed Truths*.
Berlin: Contemporary Fine Arts, 2005.

Heiser, Jorg, Katy Siegel, and Raphaela Platow. *Dana Schutz:
Paintings 2002–2005*. Waltham, Mass.: Rose Art Museum,
Brandeis University, 2006.

SEAN SCULLY
Carrier, David. *Sean Scully*. London: Thames and Hudson, 2004.

Phillips, Stephen Bennett, Michael Auping, and Anne L. Strauss.
Sean Scully: Wall of Light. Washington, D.C.: Phillips Collection,
2005.

AMY SILLMAN
Berry, Ian, and Anne Ellegood. *Amy Sillman: Third Person
Singular*. Saratoga Springs, N.Y.: Frances Young Tang Teaching
Museum and Art Gallery at Skidmore College; Washington,
D.C.: Hirshhorn Museum and Sculpture Garden, Smithsonian
Institution, 2008.

Schmuckli, Claudia, and David Lichtenstein. *Amy Sillman: Suitors
and Strangers*. Houston: Blaffer Art Gallery, the Art Museum
of the University of Houston, 2007.

TONY SWAIN
Mick, Peter, and Karla Black. *Tony Swain: Paintings*. Glasgow:
Modern Institute; Cologne: DuMont Buchverlag, 2008.

MARC SWANSON
Arning, Bill. *Marc Swanson: hurry on sundown*. Ithaca, N.Y.:
Herbert F. Johnson Museum of Art, Cornell University, 2009.

JUAN USLÉ
Yau, John. *Juan Uslé: Brezales*. New York: Cheim & Read, 2008.

ALISON VAN PELT
Komanecky, Michael K. *Alison Van Pelt: The Women*. Dayton,
Ohio: Dayton Art Institute, 2004.

TAM VAN TRAN
Sultan, Terrie. *Tam Van Tran: Psychonaut*. Houston: Blaffer
Gallery, the Art Museum of the University of Houston, 2006.

CLARE WOODS
Tufnell, Robert, and Clare Woods. *Failed Back*. London:
Modern Art, 2004.

LISA YUSKAVAGE
Gould, Claudia. *Lisa Yuskavage*. Philadelphia: Institute of
Contemporary Art at the University of Pennsylvania, 2001.